KB147428

YEON DEUNG HOE 燃燈會

LOTUS LANTERN FESTIVAL
THE LIGHT OF A THOUSAND YEARS

The Coming Together of
the World in Light and Joy

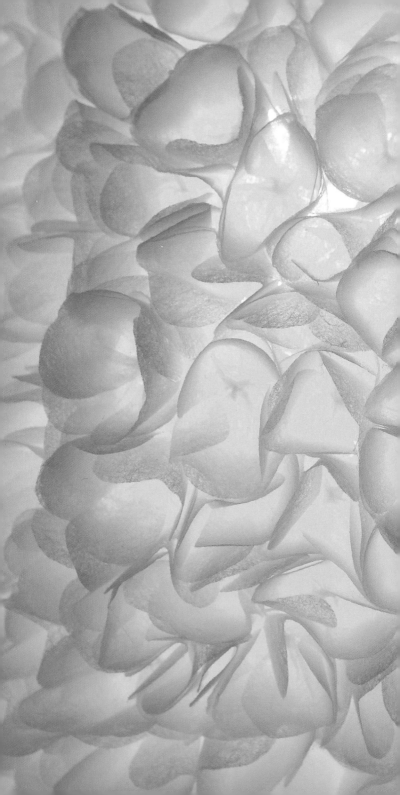

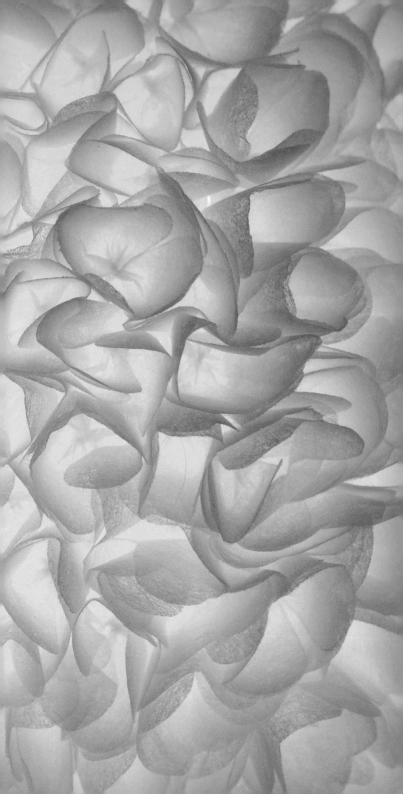

As the night falls on a spring day

There is a light in the darkness

A joyful song

A luminescent troupe

Ganggangsullae dancing

Around, round and round

We

Together as one

Yeondeunghoe,

The Lotus Lantern Festival

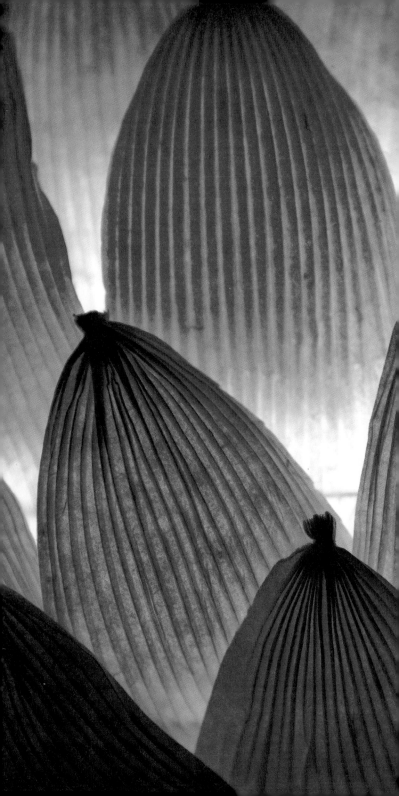

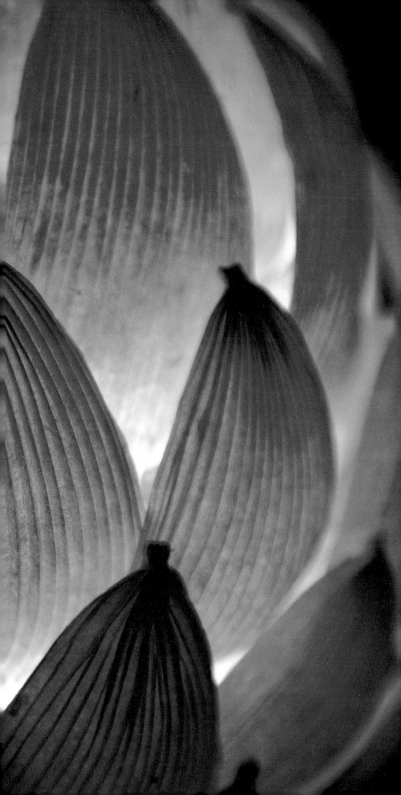

From one lantern

To a thousand,

From darkness to light

Despair to hope

Hatred to love

Ignorance to understanding

From this life

To the land of the Buddha

A light to lead us all

Yeondeunghoe,

The Lotus Lantern Festival

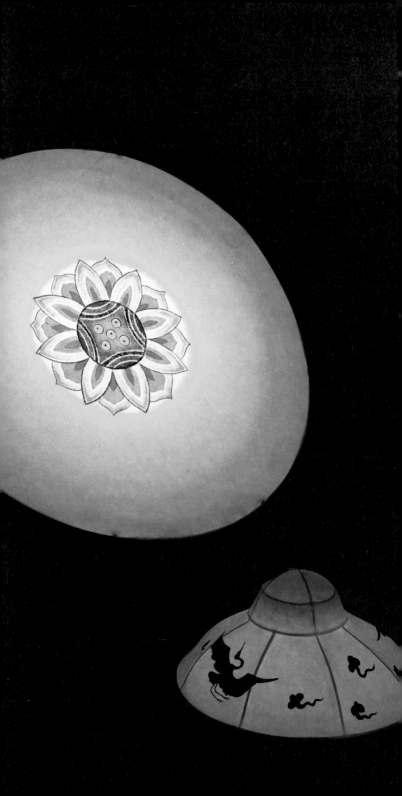

Prologue

Yeondeunghoe, meaning "lantern-lighting ceremony" and known as the Lotus Lantern Festival, is originally an event with Buddhist significance, but is now becoming a cultural festival for everyone.

The festival boasts the largest number of visitors among all Korean festivals, and also has the largest number of foreign visitors. In 2014, there were 300,000 native Korean visitors and 20,000 foreign visitors at the festival. Over 50,000 people actively participated in crafting lanterns, the lantern parade zones or *madang*• experience of the traditional cultural events and as volunteers. This high number of volunteers is one of the unique elements of the Lotus Lantern Festival.

You can find the energy of Yeondeunghoe in the Buddhist idea of the larger world where you and I are not differentiated but connected with each other. Just as a lantern brightens the world, the participants light up the festival with their time and energy for the enjoyment of all.

In each element of the Lotus Lantern Festival is the sweat and effort of many, from the individually crafted parade lanterns to the grand group lanterns constructed over the past year, the dances and songs of the Eoullim Madang and other such events.

The Lotus Lantern Festival: The Light of a Thousand Years is a guidebook for the festival's visitors and participants. The festival that brings everyone together in fun and laughter! Here we embark on the Lotus Lantern Festival this spring day. Let us remember that the festival is for the true 'I' in each and every one of us.

_ Yeon deung hoe Preservation Committee

• *Madang* (마당) _ with a literal meaning of front yard or garden, the term refers to a space of collective and communal play and recreation

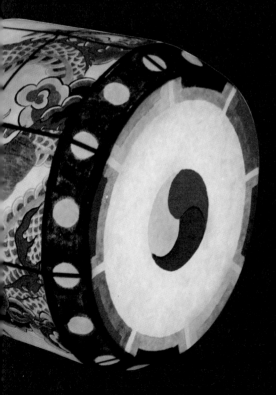

Yeondeunghoe

Meaning of the Yeondeunghoe 燃燈會

Yeondeunghoe (lantern lighting ceremony; Important Intangible Cultural Property No.122) is a traditional festival with a 1,300 year history. Continuing in the tradition, the Lotus Lantern Festival is held in prayer for the illumination of one's own mind and the world, just as the Buddha did. The festival consists of a lantern parade, lantern exhibitions, traditional cultural performances and other events.

Time

The festival is held over three days, beginning on the Friday before the Buddha's Birthday (April 8 by the Lunar Calendar). The Lantern Parade, Post-Parade Celebration and Traditional Cultural Events are held over Saturday and Sunday.

Place

Jong-ro area, Seoul, Korea

Festival

The Lotus Lantern Festival is made possible by voluntary participation. While the lanterns are made by Buddhist participants, all other events depend on the active participation of visitors. Everyone is welcome to craft their own lantern and join in the parade. All may participate in the Post-Parade Celebration and Traditional Cultural Events.

Events

Friday (Day 1)
Traditional Lantern Exhibition
• Held over 15 Days
• Jogyesa Temple, Bongeunsa Temple, Cheonggyecheon Stream

—

Saturday (Day 2)
Eoullim Madang: Buddhist Cheer Rally
• 4:30-6:00 P.M.
• Dongguk University Stadium

—

Lantern Parade
• 7:00-9:30 P.M.
- Dongdaemun, Jong-ro, Jogyesa Temple

—

Hoehyang Hanmadang: Post-Parade Celebration
• 9:30-11:00 P.M.
- Jonggak Intersection

—

Sunday (Day 3)
Traditional Cultural Events
• 12:00-7:00 P.M.
- Street in front of Jogyesa Temple

—

Cultural Performances
• 12:00-6:00 P.M.
- Performance Stage, street in front of Jogyesa Temple

—

Lotus Lantern Making for Foreigners
• 11:00-2:00 P.M. (Part 1)
 2:00-6:00 P.M. (Part 2)
- Street in front of Jogyesa Temple

—

Yeondeung Nori: The Final Celebration of the Lotus Lantern Festival
• 7:00-9:00 P.M.
- Street in front of Jogyesa Temple, Insa-dong

___ All events are organized by the Yeondeunghoe Preservation Committee.

Lotus Lantern Festival: Key Events

Pre-Parade Events

Gwanghwamun Lighting Ceremony

This ceremony announces the Birth of the Buddha and the Lotus Lantern Festival, 20 days before the Buddha's Birthday, with a prayer for the well-being of all. This event includes reciting of the Three Refuges, the *Heart Sutra*, Buddhist hymns, the lighting of the lantern, a prayer, a congratulatory address, circumambulating the lantern and a recitation of the Four Great Vows.

Lantern Competition

The objective of the Lantern Competition is the restoration and contemporary development of traditional lantern crafting. The winning lanterns of the participating groups are displayed at the Lantern Exhibition.

Daily Events

Friday (Day 1)
• Traditional Lantern Exhibition

The Traditional Lantern Exhibition recreates lantern designs described in literature, with lanterns made of traditional Korean mulberry paper (hanji). Traditional lanterns that have represented people's hopes and dreams throughout history are seen at the exhibit, along with contemporary lantern designs that continue the tradition. The exhibition begins on Friday, the first day of the festival, and continues for fifteen days.

• Cheonggye-cheon Stream Exhibition

Traditional lanterns are displayed afloat in the stream beginning at Samil-gyo Bridge. Street lanterns are also displayed.

• Bongeunsa Temple Exhibition

Colorful traditional lanterns of various shapes and material are hung at Bongeunsa Temple in Gangnam.

• Ujeong Park Exhibition

Various parade lanterns are displayed in a lantern-tunnel formation in Ujeong Park on Jong-ro.

Saturday (Day 2)
• Eoullim Madang: Buddhist Cheer Rally

Held at the Dongguk University Stadium, all parade participants gather together with the theatrical and dance troupes in a joyous celebration of unity.

Lantern-Lighting Dharma Assembly

The Buddhist service is held in celebration of the Buddha's Birthday and the Lotus Lantern Festival. It is performed in the following sequence: a *gwanbul* ceremony (sprinkling of water on the head of the Baby Buddha), ringing of the Buddhist bell, the Three Refuges (taking refuge in the Three Jewels of the Buddha, the Dharma and the Sangha), reciting of the *Heart Sutra*, an opening address, reading sutras, a prayer for reunification of Korea, *giwonmun* (aspiration prayers) and a parade proclamation.

Lantern Parade

The parade is led by a traditional royal

music ensemble, an honor guard, the Baby Buddha lantern and the Traditional Grande Lantern floats. Over 100,000 lanterns of multiple hues stream along Jong-ro.

• Hoehyang Hanmadang: Post-Parade Celebration

As the final celebration of the parade, the traditional communal play of *daedong nori* was adapted for the Lotus Lantern Festival. *Daedong* (大同) meaning 'without discrimination,' all celebrating the Lantern Parade join in without regard to age, nationality or religion.

Sunday (Day 3)
• Traditional Cultural Events

This street festival in Ujeong Park (Jong-ro) includes the Lotus Lantern Making for Foreigners, the World Buddhism Madang, the Traditional Cultural Events Madang, the Gwanbul Ceremony, the Folk Games Madang, the Food Madang, the Sharing Madang and an NGO Madang. There are over 70 programs and 100 booths operated by volunteers. Here is where you can experience various Buddhist traditions and cultures.

• Performances

The Performance Madang is presented in the performance tradition of the Korean mask-drama *(sandaehi)* and other mask performances, as well as acrobatic and magic performances as seen in the traditional Yeondeunghoe celebration. The Buddhist performances include *seungmu* (the Buddhist dance), Yeongsanjae (a celebration of Buddha's sermon on Vulture Peak Mountain) and *sachal hakchum* (monastic crane-dance).

The folk traditions of *pungmul* (Korean percussion music), *Bukcheong Sajanoreum* (Lion mask-dance of the Bukcheong region), *beona doligi* (plate or hoop spinning) and tightrope walking are also performed. Traditional folk performances of Tibet, Mongolia, Nepal and Thailand are presented as well.

• Lotus Lantern Making for Foreigners

This event is held so foreign visitors can experience firsthand making lotus lanterns, a uniquely Korean Buddhist tradition. Visitors may participate with a preregistration or on-site registration.

• Lantern Parade

As the finale of the Lotus Lantern Festival, the parade is held on the last day of the festival from 7 P.M. to 9 P.M. Grande Lantern floats and traditional performance groups are paraded from Jogyesa Temple through Anguk-dong and Insa-dong back to the intersection in front of Jogyesa.

The Buddha's Birthday Ceremony

The official Buddhist ceremony of the Buddha's Birthday is attended by various representatives of the Buddhist Orders and eminent public personages. The ceremony is held to promote the meaning and teachings of the Buddha's coming. The Buddha's Birthday Ceremony is held in Jogyesa Temple, as well as in all other Korean Buddhist temples.

contents

A Festival of Lights:
Where We Come to Shine

Illuminating the World:
A Light That Spreads Over the World

A Festival of Lights: Where We Come to Shine

Spring is a season of beauty and joy, where the world grows green again with the arrival of mild weather. Having tossed aside our heavy winter coats, we are lighter in both mind and body. We feel free and closer to the people around us.

Spring in Korea is especially beautiful and radiant. It is time for the Lotus Lantern Festival.

A spring day is embroidered with flowers. As the night falls, flowers of light blossom one by one. They are the petals of the Lotus Lantern Festival. The street fills with beautiful multi-colored lanterns, and a river of light begins to flow. Where the lanterns pass, darkness is driven out. There is light.

As we watch the lanterns flow, a spark of light ignites inside each of us, and our faces brighten. Smiles spread as we look upon each other. With this, feelings of greed, hatred and disappointment melt away. All this joy from a simple light. The transformation of darkness into light, a festival to illuminate the world and ourselves, this is the Lotus Lantern Festival. We unite as one and share our love, joy and dreams through the Lotus Lantern Festival.

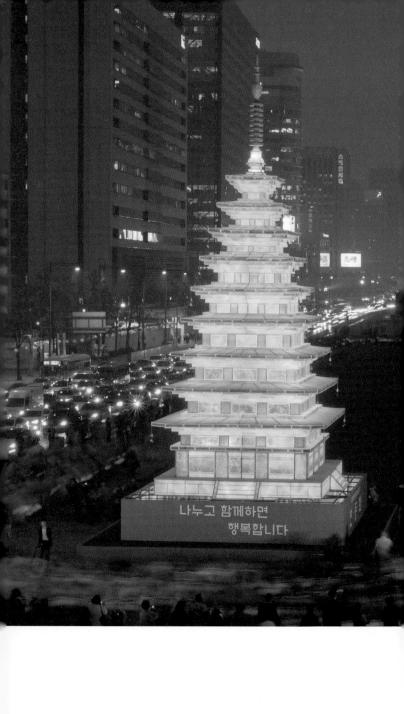

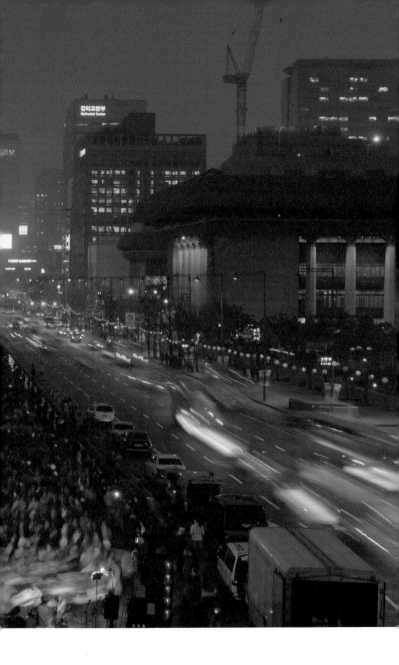

1 Festival Begins in Light

Opening of the Festival:
Gwanghwamun Plaza Lighting Ceremony

The Lotus Lantern Festival opens with the lighting of the grand lantern display at Gwanghwamun Plaza in Seoul. The Lighting Ceremony is attended by Buddhist leaders and laypeople in celebration of the Buddha's Birthday.

The grand lantern is the centerpiece of the Lighting Ceremony. Usually in the shape of a pagoda, Buddhist bell or elephant, all symbols of Buddhism, the size of the grand lantern installation is awe-inspiring. That it is made with *hanji* makes it even more impressive. The handcrafting of the grand lantern takes a minimum of six months as the framework must be built, then covered with *hanji* and then painted. Once it is lit in Gwanghwamun Plaza, people circle the installation in prayer. As the massive lantern comes to life, over 50,000 street lanterns around Seoul are also lit. The Lotus Lantern Festival has officially begun.

Gwanghwamun Lighting Ceremony 2015: Pagoda Lantern of Mireuksa Temple Site in Iksan

A unique lantern display is constructed annually for the Gwanghwamun Lighting Ceremony. In 2015, a lantern in the shape of the oldest and largest extant stone pagoda located at the Mireuksa Temple Site in Iksan (National Treasure No.11) was constructed for the festival. It was 20 m in height, including the pedestal (about 70% of the actual pagoda's size), and made with over 500 pieces of *hanji*.

*
The Lotus Lantern Festival Lighting Ceremony takes place about twenty days prior to the Buddha's Birthday in Seoul's Gwanghwamun Plaza. You may check the exact date of this year's ceremony on the Lotus Lantern Festival homepage (www.llf.or.kr).

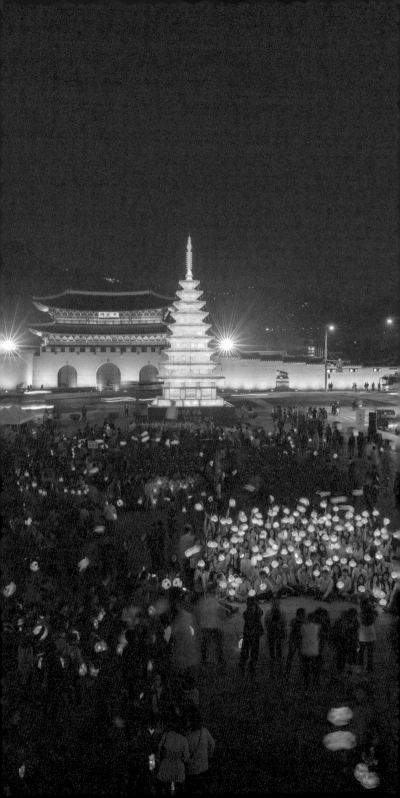

1976

1977

History of the Lighting Ceremony Installations: Representing the Beauty of the Era

In the 1980s, the Lighting Ceremony's lantern installation was in the shape of a pagoda to commemorate the Buddha's Birthday. The pagoda was made so that it could be used over and over into the 1990s. From 1996 on, a new and different lantern was constructed every year in various shapes: the Baby Buddha, a lotus flower and other such Buddhist designs. Traditional *hanji* paper has been used to make the grand lantern installation since 2008.

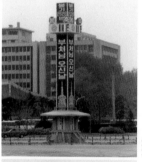

1982

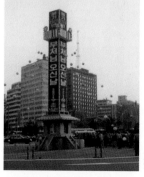

1984

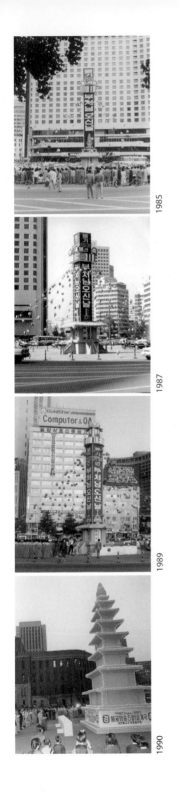

1985

1987

1989

1990

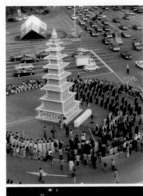

1994

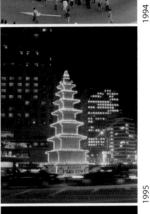

1995

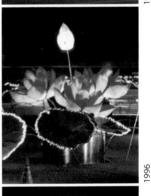

1996

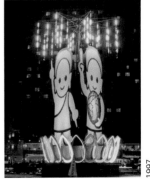

1997

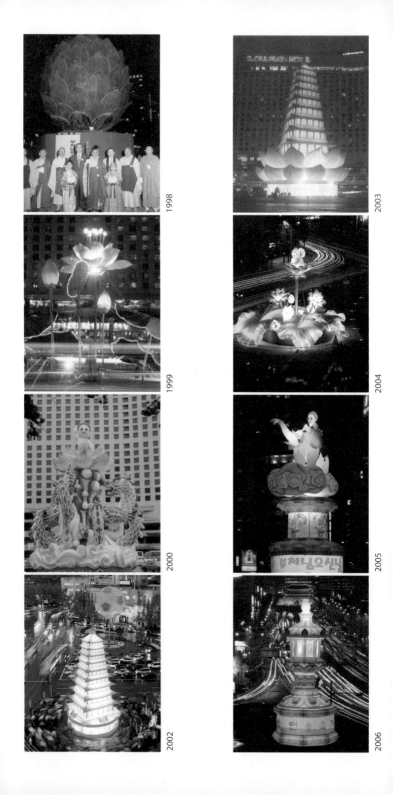

1998

2003

1999

2004

2000

2005

2002

2006

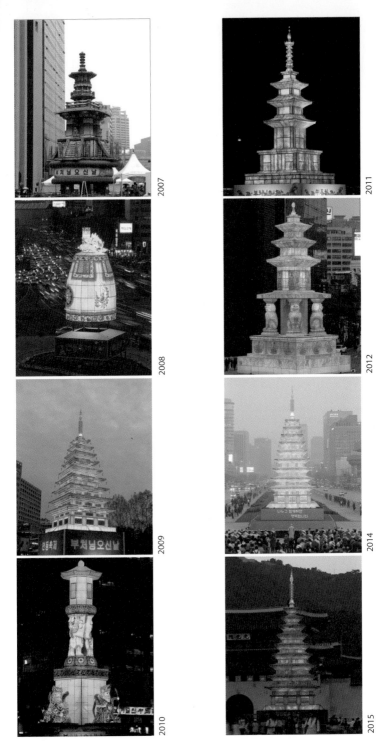

2007

2008

2009

2010

2011

2012

2014

2015

Blossoms of the Lotus Lantern Festival: Traditional Lanterns

Atop a hill on the Buddha's Birthday,
Here to see the lanterns.
In the distance is the setting sun,
Lights of Fish and Dragon, Phoenix, Cranes, Turtles,
Bells, Immortals, Drums,
Watermelon, Garlic Cloves, Palanquins, Railings,
Doll-atop-lion, Barbarian-atop-tiger.
By the foot kicked and curved the lanterns,
Lights of the Sun and the Moon, the Big Dipper.
The moon rising to the east, sparks everywhere,
Where is my love, be here for the lanterns.

___ The *Gwandeung-ga* (Unknown, Joseon period)

As described in the Joseon-era ballad the "*Gwandeung-ga*," traditional lanterns came in various shapes. Lanterns are the main characters of the Lotus Lantern Festival. Traditional *hanji* lanterns emit the warmth and beautiful hues representative of Korea. Various events are held around the Lotus Lantern Festival, bringing back to life long lost traditional lantern designs and reinterpreting traditional designs with a contemporary flair. Let's immerse ourselves in the graceful beauty of traditional lanterns with over 1,000 years of history.

Traditional Grande Lanterns

The two main categories of lanterns in the Lotus Lantern Festival are the Grande Lanterns and Parade Lanterns. Grande Lanterns are a group project from start to finish and are designed to be in the final parade, where all participants work together as one. Their construction takes over six months on average. Each Grande Lantern embodies the wish and yearning to brighten the world, and each has a meaning represented by its shape.

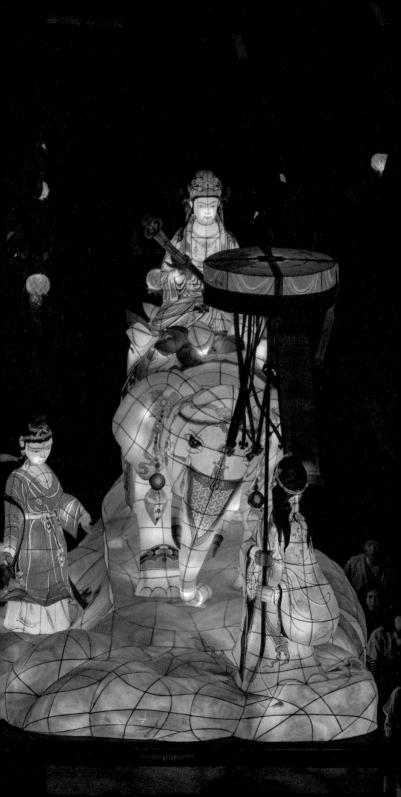

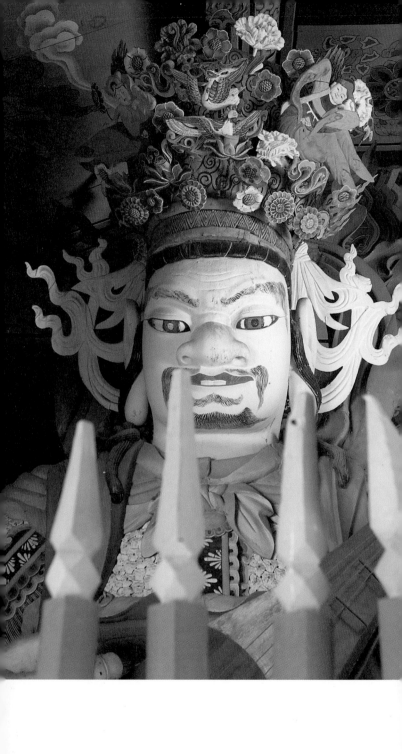

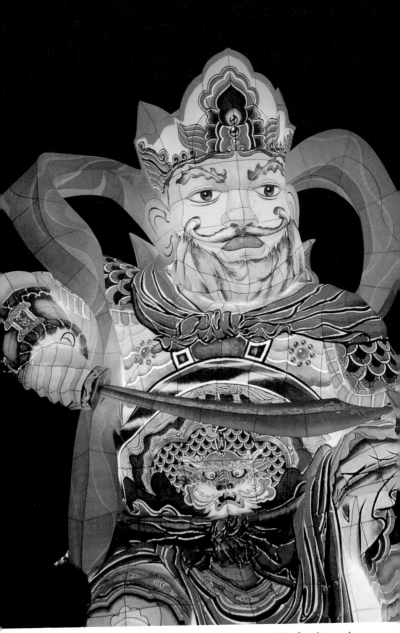

Four Dharma Protectors Lantern (*Sacheonwang-deung*) _ The four heavenly guardians of the Dharma, known collectively as Sacheonwang, protect the universe in all four directions. Do not be afraid of their fierce eyes and armor. They are protective entities who guard against evil. The Four Dharma Protectors Lantern, painted in strong, vivid colors, appears at the head of the parade escorting the Baby Buddha.

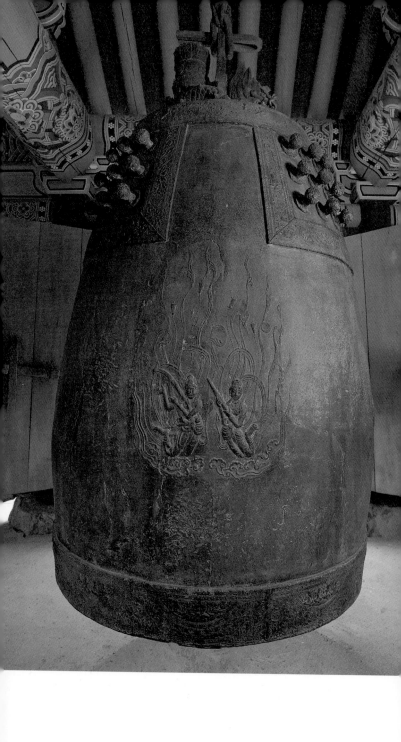

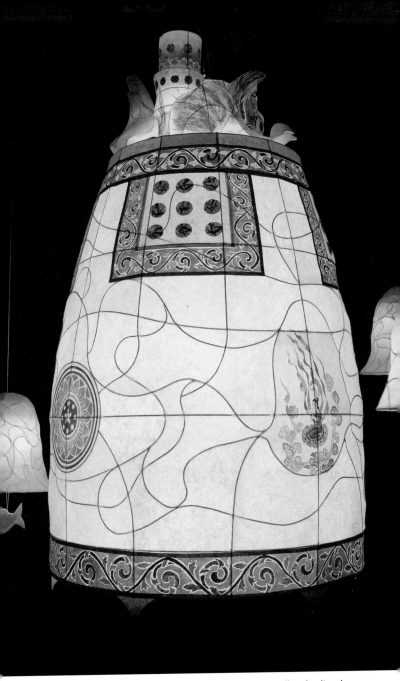

Buddhist Bell Lantern (*Beomjong-deung*) _ The Buddhist Bell embodies the compassion and aspirations of the Buddha. Upon hearing its sonorous tone, all sentient beings can overcome their ignorance and attain wisdom. It also saves those trapped in hell. Gleaming and ready to sound a note of unmatched clarity, the lantern is a replica of King Seongdeok's Divine Bell, considered an outstanding example of ancient Korean metalcraft.

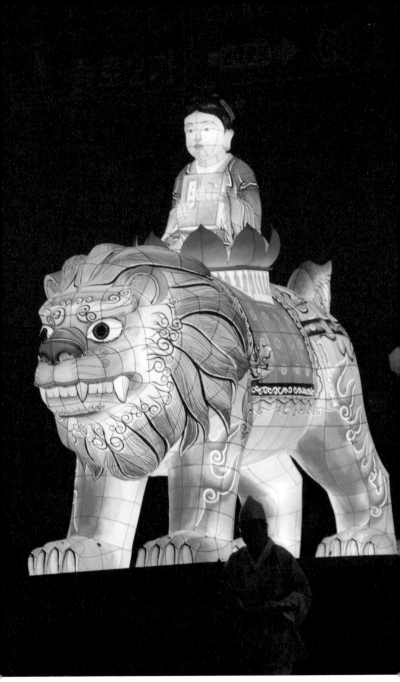

Lion Lantern (*Saja-deung*) _ The lion has a deep connection with Buddhism. Manjusri Bodhisattva (the Bodhisattva of Great Wisdom) rode atop a lion, and many Buddhist altars and pagodas have a lion motif. The lion represents the wisdom of the Buddha. As all animals recoil at the cry of the Lion King, the truth of the Buddha drives out all false views. Dharma discourses of the various Buddhas are referred to as "the Lion's Roar"(*Sajahu*).

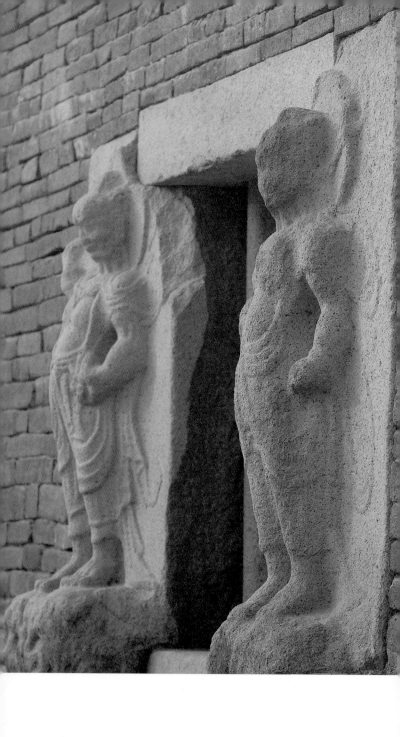

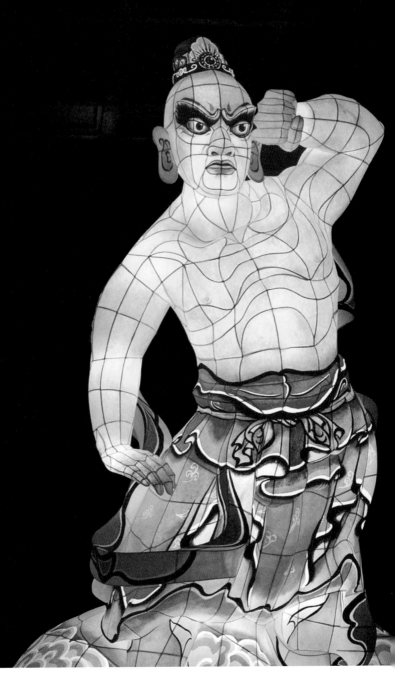

Diamond Deva Lantern (*Geumgang-yeoksa-deung*) _ The Diamond Devas guard the Buddha-dharma at the entrance of temples and act as gatekeepers. The wire bones of the divine Deva lantern add dimensionality to their muscular arms.

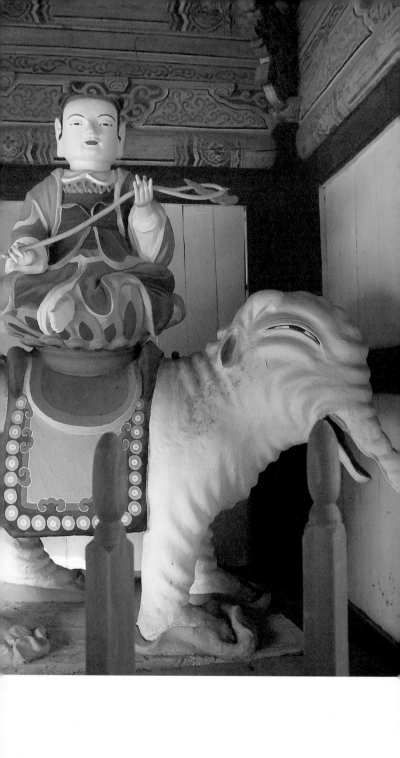

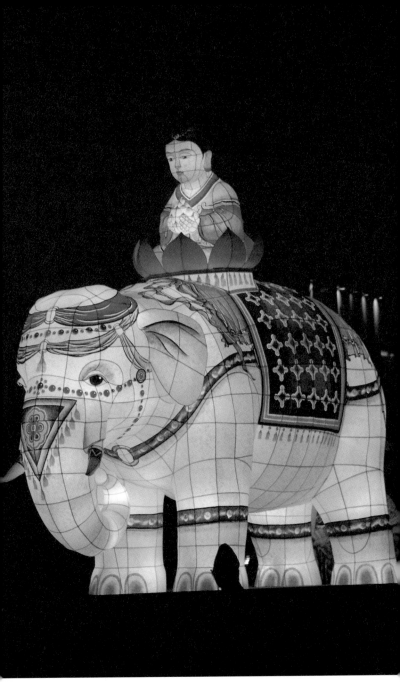

Elephant Lantern (*Koggiri-deung*) _ Queen Maya of Shakya, the birth mother of the Buddha, dreamt of a white elephant entering her right side, a prediction of her future conception. In connection with the birth of the Buddha, the white elephant is a popular theme in lantern making. While sculptures of the Buddha are seen in parades atop live elephants in South East Asia, elephant lanterns fulfill that role in Korea.

Parade Lanterns

Parade lanterns are small hand-held lanterns carried in the parade. Each parade lantern embodies the devotion and wishes of its holder, and each is unique. No longer in use are manufactured plastic lanterns. Traditional *hanji* lanterns are now more prevalent with guidance from the Yeondeunghoe Preservation Committee in its efforts to recreate and preserve old traditions. Each year we are seeing more unique lanterns that exhibit a contemporary flair and creativity.

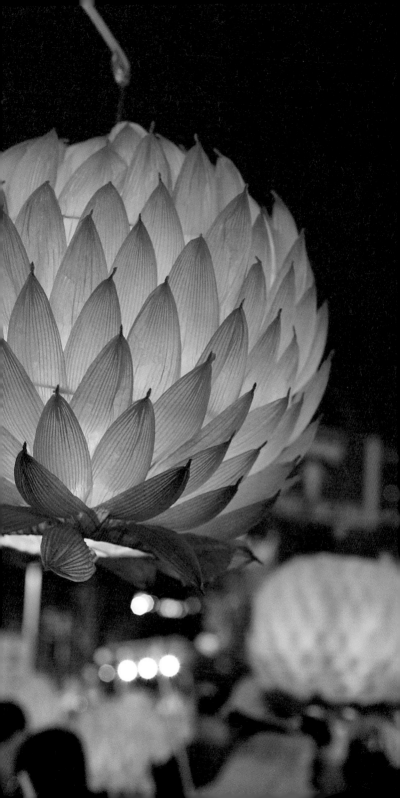

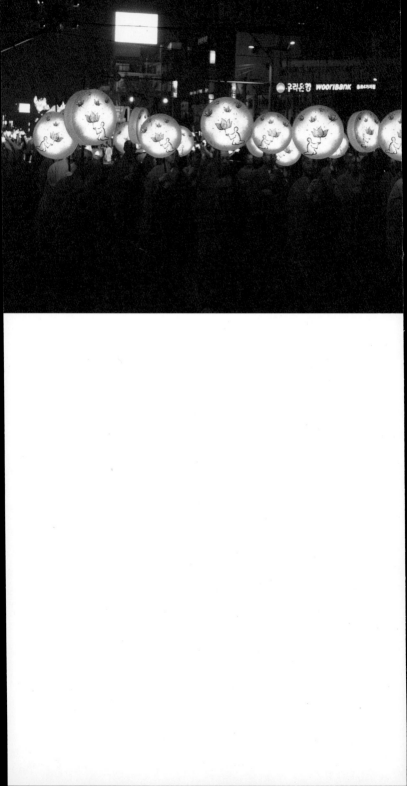

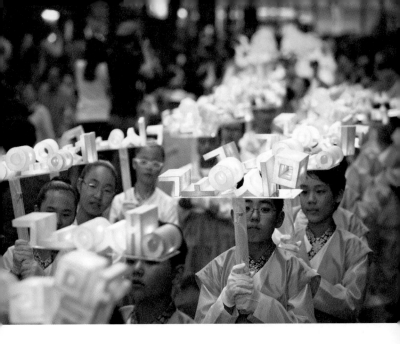

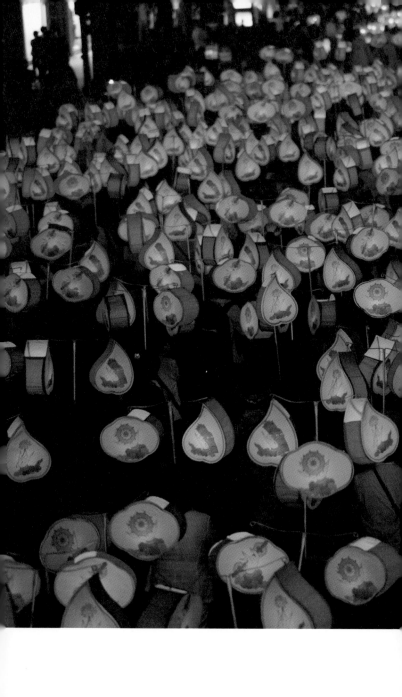

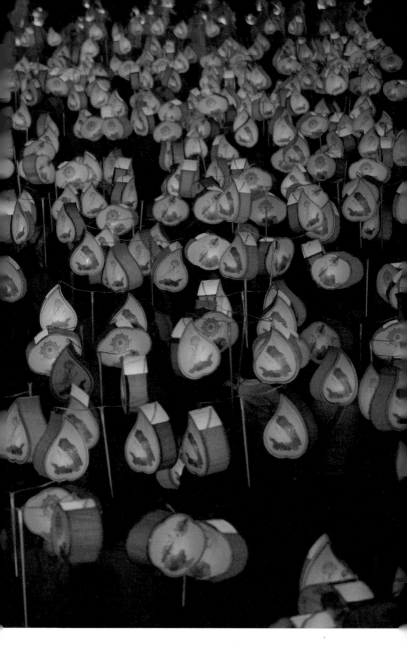

Traditional Lantern Exhibitions

If you want to see the beauty of traditional lanterns up close, the Traditional Lantern Exhibitions at Bongeunsa Temple, Cheonggyecheon Stream and Ujeong Park (by Jogyesa Temple) are highly recommended. The best time to see the exhibitions is after sunset, but it is also nice during the day. It is also interesting to see the difference before and after the lanterns are lit. The immensity of the grand floating lanterns and the charm of the small parade lanterns, all imbued with the maker's hopes and dreams are beautiful to see. The effort of each individual is where the lantern's beauty comes from.

Bongeun-sa Traditional Lantern Exhibition

A Traditional Lotus Lantern Exhibition has been held at Bongeunsa Temple (Gangnam-gu, Seoul) since 1989. The exhibition continues Korea's cultural tradition and promotes traditional lantern making along with the Lotus Lantern Festival. Both the works of professional artisans and those selected from the Traditional Lantern Design Competition are displayed. Lantern designers borrow their themes from Buddhism, Korean traditional fairy tales and even comic books. The quality and artistry of the lanterns reach new heights every year. The creativity of the professional artists, the sometimes whimsical nature of amateur's creations and the colorful children's lanterns all come together to present a great show.

*
The Traditional Lantern Exhibitions begin on different dates at different locations, but most commence on the first Friday of the Lotus Lantern Festival for fifteen days. Bongeunsa Traditional Lantern Exhibition is open from 9 A.M. to 10 P.M. The lanterns are lit between 7-10 P.M.

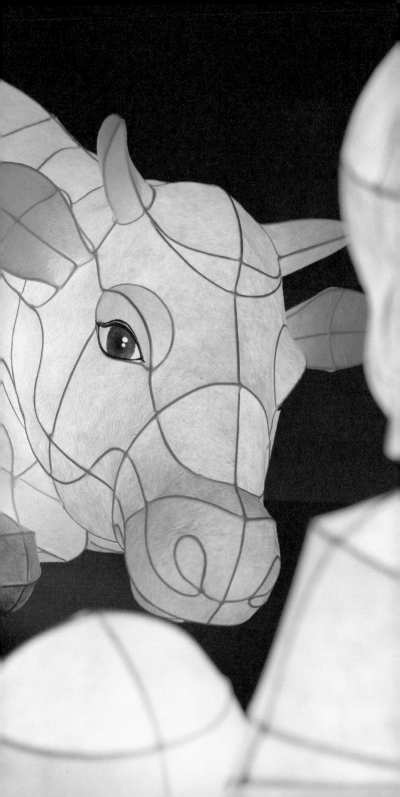

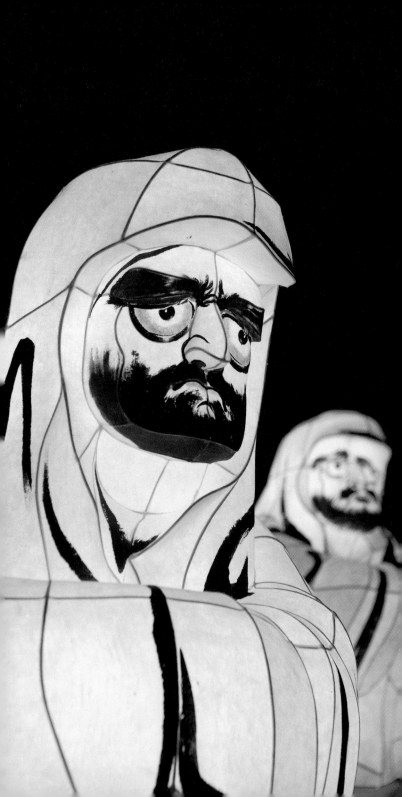

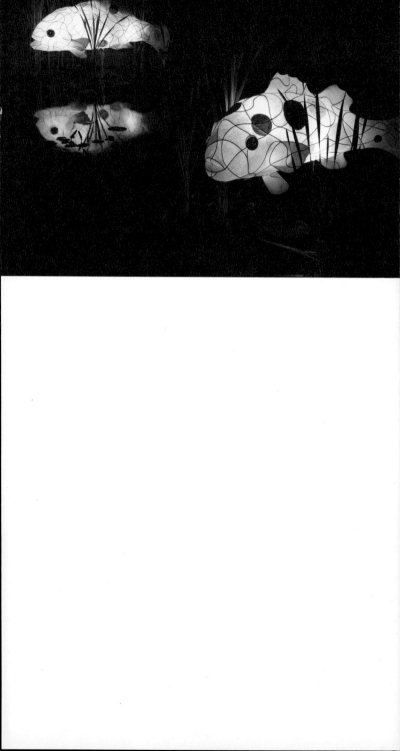

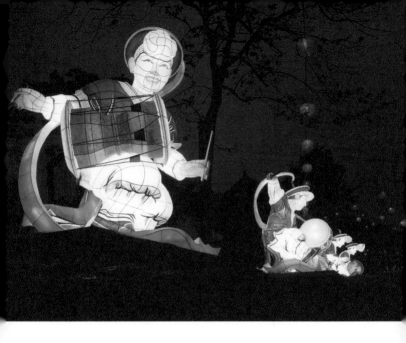

Cheonggye-cheon Traditional Lantern Exhibition

At the Cheonggyecheon Traditional Lantern Exhibition, both floats and street lanterns are displayed along the stream. There is something magical about seeing lanterns afloat on the water. During the day, one is awed by the size and splendor of the grand lanterns, and in the evening, entranced by the lanterns' light reflected in the stream. The street lanterns shine like stars descended from heaven. This is definitely an exhibition not to be missed.

Expressions and Movements of the Lanterns
The lantern characters seem about ready to come to life. The artists' efforts in the making of every expression and gesture is palpable. Their sometimes comical expressions will have you smiling, while their dynamic gestures will imbue you with energy.

*
Are the Lanterns Displayed in Rain or Snow?
Most traditional lanterns made of *hanji* paper at the exhibitions are waterproofed to prevent weather damage.

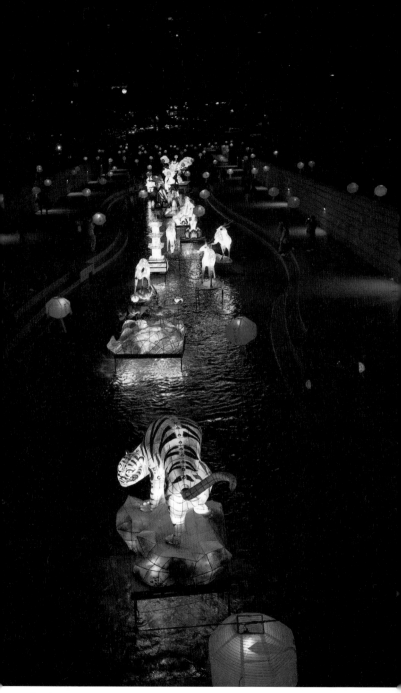

Floating Lanterns and Street Lanterns _ The Lotus Lantern Festival begins with the exhibition of traditional lanterns and street lanterns along Cheonggyecheon Stream in Seoul. After sunset, the colorful street lanterns shine like stars.

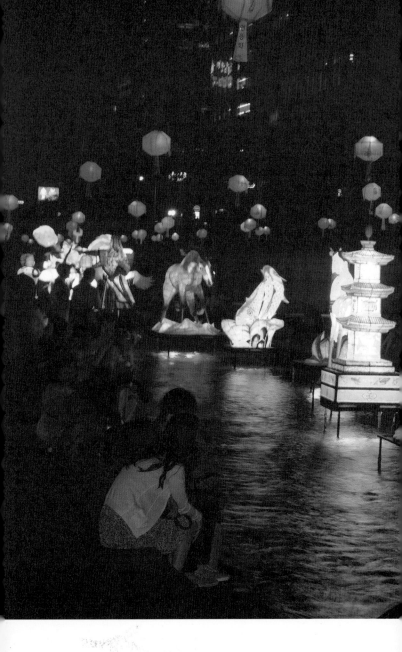

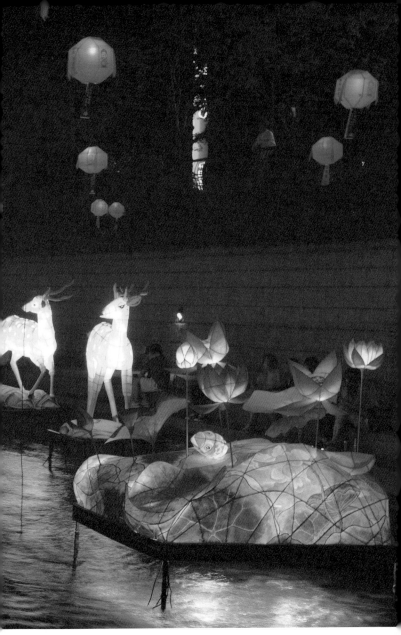

Floating Lanterns in the Water _ The traditional lanterns afloat in Cheonggyecheon Stream are a sight to behold. Well-designed lanterns shine evenly through every surface. The warm light of the *hanji* paper lanterns contrasts harmoniously with the cool stream and is indescribably beautiful.

Ujeong Park Traditional Lantern Exhibition (Jogyesa Temple)

In and around Jogyesa Temple, small parade lanterns are on display, unlike the grand lanterns at the Bongeun-sa and Cheonggye-cheon Exhibitions. The Ujeong Park Traditional Lantern Exhibition creates lantern-tunnels each year. One can readily fall into a joyous trance looking up at the parade lanterns in all colors and shapes. The soft light of the lanterns creates the perfect backdrop for a very memorable photo. At the Templestay Information Center across from Jogyesa one can see some unusual lantern displays. Here, displayed on long poles, are recreations of traditional lanterns in various shapes (watermelons, garlic cloves, octagons, carp) and even silk lanterns. New parade lanterns made using traditional methods but with contemporary designs appear each year. How about searching for your favorite design to carry in next year's parade?

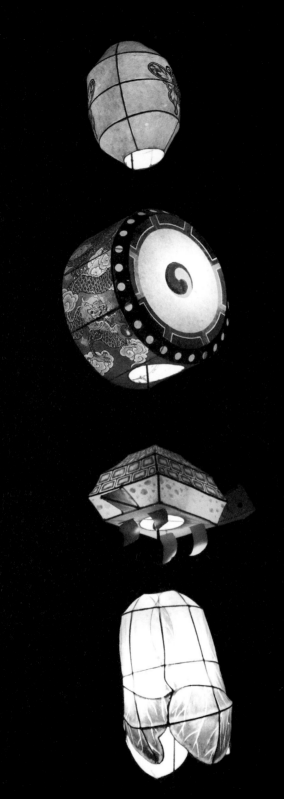

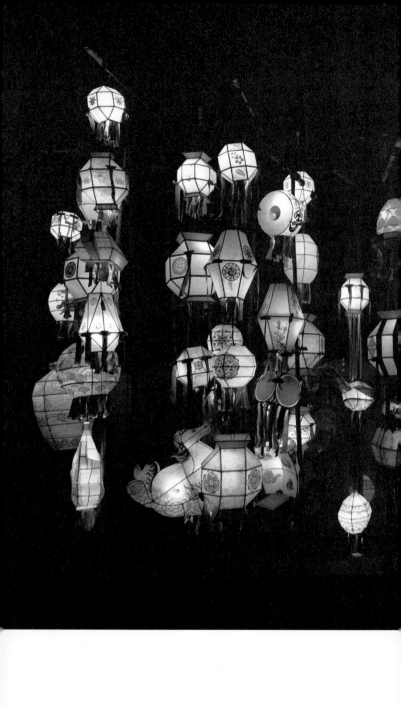

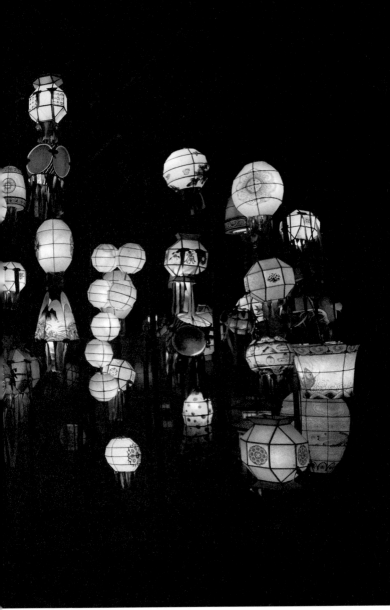

The lantern-poles (*deung-gan*) display lanterns recreated using traditional lantern-making craftsmanship.

Traditional Lanterns of the Past Recreated

Traditionally, lanterns were made in different shapes and from different materials depending on how they would be used. Lanterns were often designed to diffuse light, rather than direct light to a certain area. This design, called *deungrong*, had a frame of bamboo or iron, covered in paper or fabric, with a candle hung inside. *Dongguk sesi-gi*, a record of the traditional seasonal customs of late Joseon period, describes methods of lantern crafting.

"In lantern making, the framework is made of bamboo which is covered with paper or red and blue silk. Mica is sometimes inserted, with drawings of flowers, hermits or birds in flight. On the plain surfaces and angled points may be attached long rolls of tri-colored paper that flutter in the wind, adding to the style."

Lantern designs took on variations for celebrations like the Buddha's Birthday. People made uniquely individual lanterns, lighting them with expectations that their hopes and aspirations would be fulfilled. Traditional lanterns embody traditional Korean culture, sentiment and history. The Yeondeunghoe Preservation Committee has continued its efforts to revive traditional lantern making since 1996, with a good number of Korean traditional lantern designs researched and recreated. Research material on traditional lanterns was rare in the early stages of their restoration efforts. Lyrics of folk songs such as the *Deung taryeong* ("Lantern Song" : traditional Korean ballad from Chungcheong-do region) were used for reference, along with the counsel of elder monks. In the continuing lantern restoration research, a total of 24 traditional lanterns in the shapes of phoenixes, watermelons and carp have been recovered and recreated.

Traditional Lantern Making Classes

Making a traditional lantern has many steps, but it is not as difficult as it may seem. For those interested, there are traditional lantern making classes held every fall at the Memorial Hall of Korean Buddhist History and Culture (by Jogyesa Temple). The Yeondeunghoe Preservation Committee has hosted the classes since 2000 to share their research into the restoration of traditional lanterns. Participants must preregister, and there are two courses, one for parade lanterns and another for grand lantern floats. The parade lantern class is a prerequisite for the grand lantern class. Each course lasts 2~3 days. Professional artisans teach the entire course, from building the frame, attaching the *hanji* paper and coloring the lantern, to the final stages of wiring and lighting the lantern. Those who attend the classes can then transmit what they learned to other temples and organizations to continue the tradition. Some of the lanterns made in class are sent to other locations to further disseminate the traditional lantern crafts.

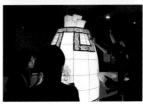

*
Traditional lantern making classes are held regularly in November of each year. Those interested in learning the craft may check the official Lotus Lantern Festival homepage for the exact schedule and how to register.

Lantern Competition

While the grand lanterns may astound, it is the parade lanterns that participants of the Lotus Lantern Festival pour most of their energy into. The Group Parade Lantern Competition is held by the Yeondeunghoe Preservation Committee to promote the popularization and restoration of traditional Korean lanterns. The entries must be made by participants of the Lantern Parade. Until the Joseon period, there was a popular tradition of hanging a lantern at the gate of each house, embodying the wishes of each household. In reviving this tradition, the parade participants are asked to create lanterns of their own.

Winners of the competition are judged for their unique interpretations of traditional styles and for their craftsmanship. Additional points are given for lanterns created by the parade participants themselves. Prizes are handed out at the Eoullim Madang on the day of the parade. During the awards ceremony, competing groups cannot hide their excitement and neither can the cheering crowd. There is also a Youth Lantern Exhibit.

*
The lantern competition is one of the hidden gems of the Lotus Lantern Festival. Along with the restored traditional lanterns, the newly created lantern designs are a joy to behold. Prize-winning entries in the Group Parade Lantern Competition are featured in a publication, supporting research into the cultural heritage of traditional lanterns.

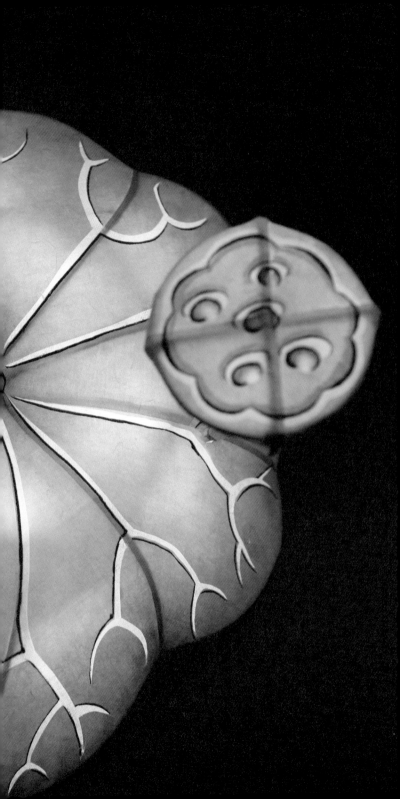

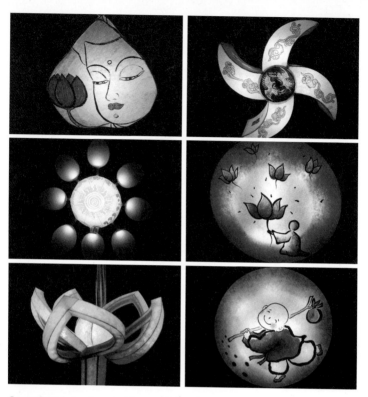

Group Parade Lanterns _ The parade lanterns are constructed with *hanji* on wire frames, and decorated with drawings and paintings. There are hundreds of parade lanterns in the Lotus Lantern Festival, together creating a marvelous moving spectacle.

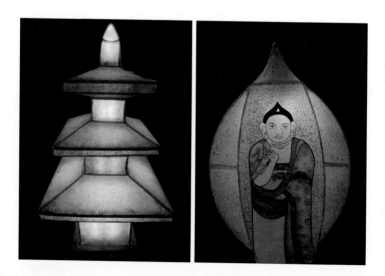

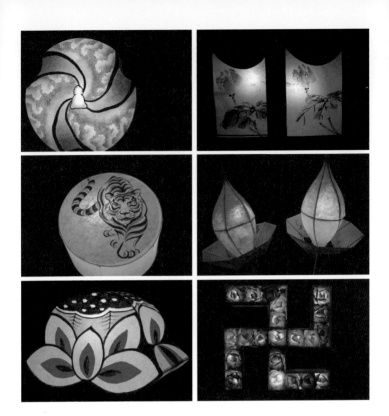

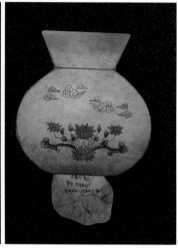

Youth Lantern Exhibit _ The lanterns of younger participants at the festival embody creative and novel ideas. They may not be the most polished lanterns, but their flair for imagination is among the best. The exhibit is held to introduce the younger generation to the Lotus Lantern Festival, so that they create and participate in the festival themselves.

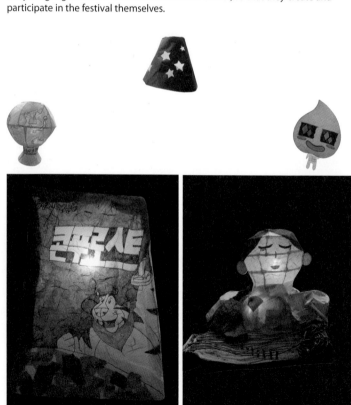

Newly Discovered and Recreated Traditional Lanterns in 2014

The Traditional Lantern Workshop has been hosted by the Yeondeunghoe Preservation Committee since 1997, and their goal is to recreate lanterns referenced in literature. Recreated in traditional materials, including steel wire, *hanji* and *jihwa* (paper flowers), the process is entirely handcrafted. Once commonly used as lantern material, plastic has been wholly replaced by *hanji* paper. In 2014, eleven traditional lantern designs were recreated in the shapes of traditional Korean musical instruments.

An exhibit is held to display restored traditional lanterns. The lantern making process discussed at the conference is used by temples and organizations to create lanterns for the Lantern Parade the following year.

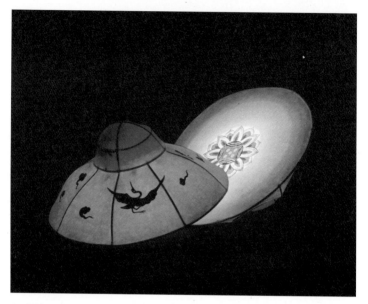

Buddhist Cymbal Lantern (*Dongbal-deung*) _ *Dongbal* is a traditional Korean cymbal made of copper or steel. It was often used in Buddhist dance ceremonies and *nongak* (traditional Korean music of agricultural region). A large *dongbal* is used in Buddhist ceremonies.

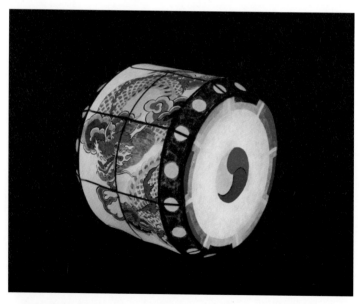

Drum Lantern (*Buk-deung*) _ A percussion instrument, the Buddhist *buk* is also called a *beopgo* or Dharma drum. It is an important instrument in Buddhist ceremonies and dance rituals. The sound of the Dharma drum delivers the Buddha's teachings to the animal kingdom.

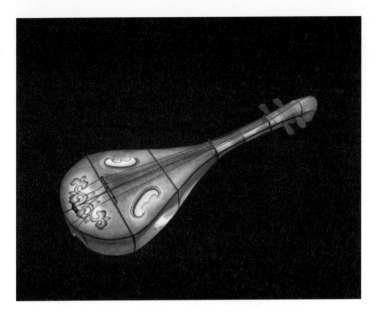

Lute Lantern (*Bipa-deung*) _ A *bipa* is a traditional Korean string instrument with four or five strings. Thought to have been used in Buddhist music, the upper cover of a gilt-bronze incense burner from Baekjae shows a carving of five musicians playing a *bipa*, a *piri* (pipe), a *baeso* (a wind instrument used in court music), a *hyeon'geum* (harp) and a drum.

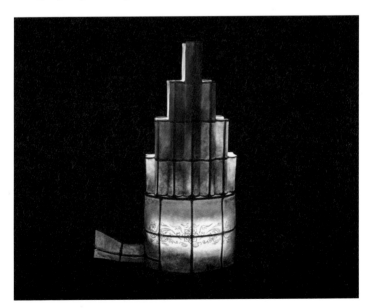

Reed Pipe Lantern (*Saenghwang-deung*) _ A wind instrument of Korean court music, it is thought to have been played since the Three Kingdoms Period. Images of it appear on the Sangwonsa Temple Bell and King Seongdeok's Divine Bell.

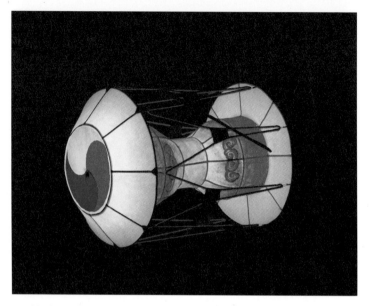

Double-headed Drum Lantern (*Seyogo-deung*) _ A type of Korean double-headed drum (*janggu*), its narrowed middle has given it the name *seyogo* (narrow-waisted) or *janggo*. Pictures of the drum are found in ancient tomb murals of the Goguryeo period and on Buddhist temple bells from Silla.

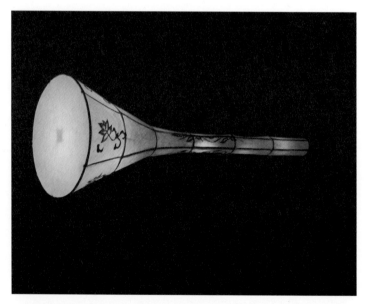

Horn Lantern (*Taepyeongso-deung*) _ *Taepyeongso* is a kind of a brass horn used in the Korean traditional music including the ritual music for royal ancestral ceremony; royal military marching band music; farmers' folk music; and Buddhist songs and hymns.

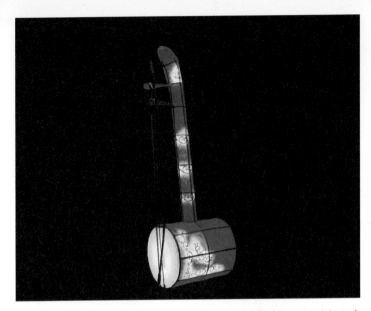

Fiddle Lantern (*Haegeum-deung*) _ A string instrument, the *haegeum* originated in the Tang and Song Dynasties of China and was used in popular music. It was employed in the traditional music of the Goryeo period in Korea.

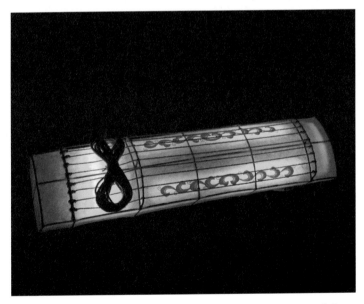

Jaeng Lantern (*Jaeng-deung*) _ This 7-string instrument in the category of *ajaeng* was used mostly in court ceremonies. It has a larger body and thicker strings than the *gayageum* (a zither-like 12-stringed instrument).

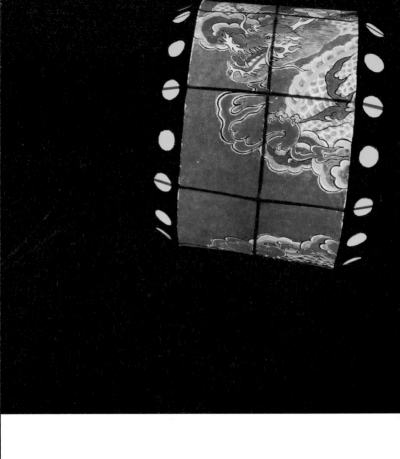

Lotus Petal Lantern (*Yeon'ggot-deung*) _ An octagonal lantern of lotus petals. Lotus petals are difficult to fold into shape; with a special tool designed for their construction, lotus petal lanterns have grown more popular. This lantern is a handmade recreation.

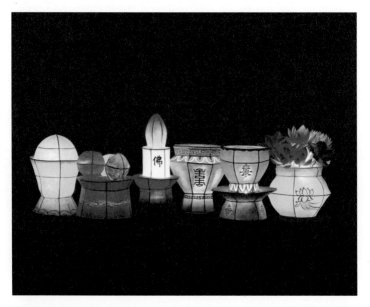

Six Offerings Lantern (*Yukbeop gongyang-deung*) _ Lanterns in the shape of the six offerings (*pujana*) in a Buddhist ceremony: incense, candle, flower, fruit, tea and rice.

Hand Lantern (*Chorong-deung*) _ Popularly called *tosi-deung* (*tosi*: arm-warmers) for its shape, the lantern is made of paper or fabric. Once commonly used in monasteries, paper *chorong-deung* are no longer in use. Fabric lanterns like *cheongsa-chorong* (red-and-blue silk shade) are in use today.

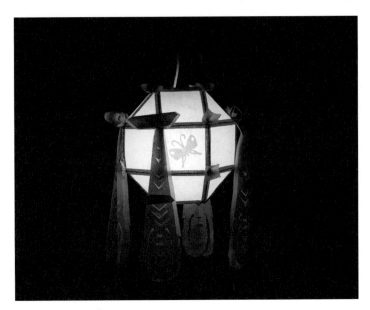

Octagonal Lantern (*Palmo-deung*) _ One of the most popular traditional lanterns in use today, various contemporary designs have been developed using a common frame.

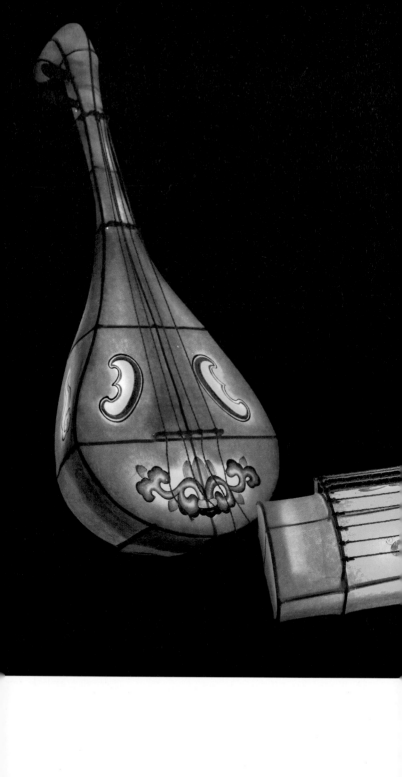

2 A Festival Where the Participants Are the Heroes

There are no main characters at the Lotus Lantern Festival. It is a festival where everyone joins in of their own will. The beautiful lanterns, the people in the parade and the spectators are heroes on this day, the characters in this story. At the Lotus Lantern Festival, everyone comes together without regard to age, nationality, gender or religion.

Eoullim Madang: A Place of Joy and Togetherness

Waiting can make time seem to drag by. If waiting for the Lantern Parade bores you, you can get an early start on the festivities at the Eoullim Madang, the pre-parade cheer rally. The Eoullim Madang begins at 4:30 P.M. in Dongguk University Stadium. This is where thousands of people participating in the parade come together in joy and excitement, representing over 200 organizations who help put the festival together. Time will fly watching the dance and theatrical troupes showing off the routines they have mastered set to lively music. There is also the Lantern Lighting Dharma Assembly to commemorate the festival. The Eoullim Madang is where all participants of the festival come together in song and dance, building up excitement and anticipation for a dynamic festival. Originally held at Dongdaemun Stadium (demolished in 2008), the Eoullim Madang has been held at Dongguk University Stadium since 2009.

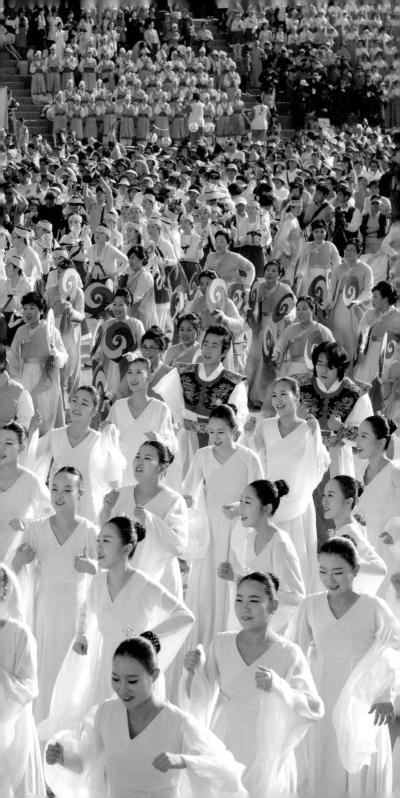

Dance Troupes

The Eoullim Madang opens
with the children's dance troupe.
Everyone is in smiles watching
the elementary school students'
adorable moves. Every so often,
a child may freeze up, startled at
the big crowd, and everyone will
cheer in encouragement. The youth
and young adult troupes follow the
children. Many students commit
themselves to the Lotus Lantern
Festival, practicing diligently in
their free time. Here they pour out
their energy, burning off stress.

*
**Eoullim Madang: Buddhist
Cheer Rally**
• Time
**Saturday 4:30-6:00 P.M.
(Day of the Lantern Parade)**
• Place
Dongguk University Stadium
• Transportation
**Subway Line 3: Dongguk
University Station**

You can come to Jong-ro after
the Eoullim Madang, in time
for the parade. Attending
the Eoullim Madang is
recommended for a full
experience of the Lotus
Lantern Festival.

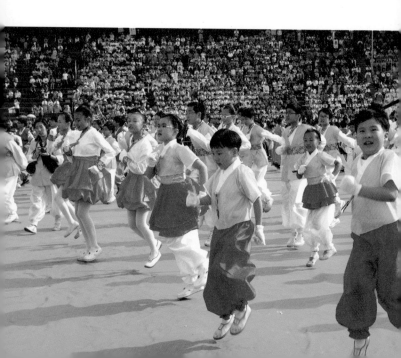

Dance Troupes _ The children's dance troupe in *hanbok* (traditional Korean dress) moving to the dance routines are the most adorable. The smiles of the children send people back to a time of innocence, as everyone comes together at the Eoullim Madang.

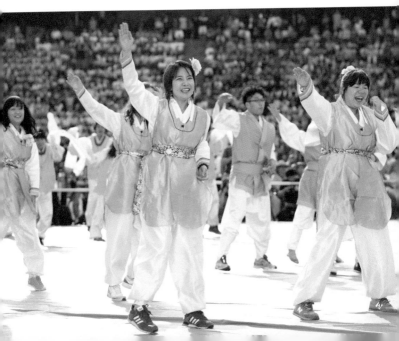

Theatrical Troupes

The theatrical troupes dancing to the official Lotus Lantern Festival song are not professional dancers but ordinary people who have practiced for months in preparation for the festival. This is a festival where each person is a hero. A missed step or two sends people into laughter. Once the troupes demonstrate the routine on five platforms, everyone at the Eoullim Madang learns the dance and festival song together. Watching the performers and the audience dance in unity is quite a sight, made all the more meaningful in the unity of young and old.

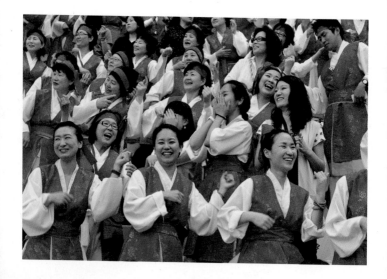

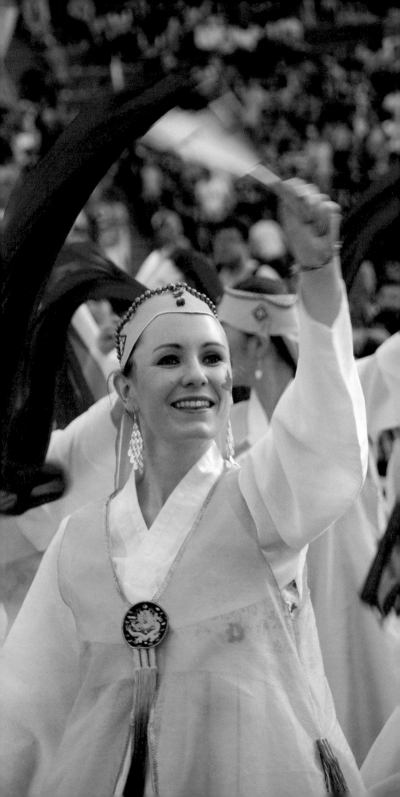

Song and Dance of the Lotus Lantern Festival

Song and dance at festivals double the fun. Before 2000, this part of the festival was held as part of the Lantern Lighting Dharma Assembly. The Yeondeunghoe Preservation Committee then created a separate event called the Eoullim Madang and incorporated song and dance, turning it into a fun-filled festival for everyone watching and participating. The change was a process. At first, when popular music was introduced to the rally, it was noted that, while exciting, the music did not fit the traditional form of the Lotus Lantern Festival. Beginning in 2005, "Song of the Lotus Lantern Festival" was composed with a public contest to create new lyrics that would promote the original content of Buddhist hymns and dances. The Lotus Lantern Festival song has a rhythm and lyrics easily learned by the general public. The song expresses the mood of the festival. As befitting a traditional festival, Gugak and traditional Korean musical instruments are often used. Once the official song is selected, dance routines are created for the music. They are simple routines for everyone from children to the elderly to join in. You can preview the song and dance routines on the Lotus Lantern Festival homepage for more fun at the festival.

The song and dance routines of the Lotus Lantern Festival stir up excitement and energy at the Eoullim Madang. There is now an annual contest to write new lyrics for the Lotus Lantern Festival Song, which professional composers then set to music.

The Group Parade Lantern Competition

At the Eoullim Madang, awards are presented for the Group Parade Lantern Competition. This is done prior to the Lantern Lighting Dharma Assembly.

Those awarded top prizes, along with other winning entries, are eagerly cheered by the crowd. The awards serve to promote diversity in traditional lantern design and continued development of the Lotus Lantern Festival through friendly competition. Some amazingly diverse and creative parade lanterns are submitted each year for the competition. Individual groups design and craft their own lanterns for months ahead of the festival.

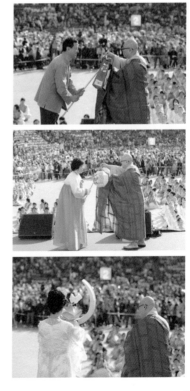

Gwanbul Ceremony

Following the awards ceremony
is the Lantern Lighting Dharma
Assembly. The service begins
with the *gwanbul* ceremony where
a sculptural representation of
the Baby Buddha is bathed with
purification water. This ceremony
originates from a story about the
Buddha's birth in the Lumbini
Garden where nine dragons are
said to have bathed the Baby
Buddha in pure fragrant waters.

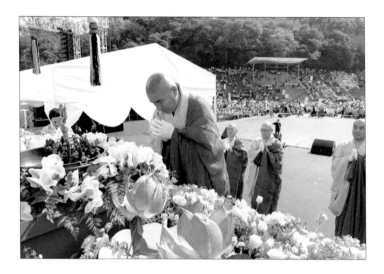

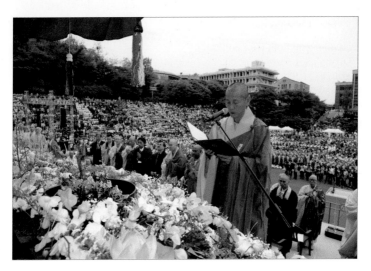

Lantern Lighting Dharma Assembly

The Lantern Lighting Dharma Assembly is the most ceremonial Buddhist event at the festival. Now an international festival, the Lotus Lantern Festival is a traditional Korean festival with 1,300 years of history and deeply rooted in Buddhism. The Lotus Lantern Dharma Assembly celebrates both Buddha's Birthday and the Lotus Lantern Festival.

With the long Buddhist hanging scrolls (*gwaebul*) and the platform decorated with traditional handcrafted paper-flowers, the atmosphere is solemn and stately. The ceremonial water (*gwanjeong-su*) used in the ceremony is brought in from Mt. Odaesan (Gangwon-do Province), where the holy sarira of Shakyamuni Buddha is enshrined. All at the ceremony, including Buddhist monastics, Buddhist laity and foreign tourists, commemorate the Buddha's teachings. "In the realm of wisdom, loving kindness and compassion, you and I do not differ. The road to peace and happiness opens when we overcome greed and ignorance."

Parade Proclamation

Full of energy from the Eoullim Madang rally, parade participants begin the march with a reading of the parade proclamation. The anticipation is palpable. With the same lead group at the head of the parade every year, five other groups follow; their order may vary year to year.

*
The parade begins at Dongguk University. As it meets with the grand lanterns at Heunginjimun Gate (Dongdaemun Gate), the Lantern Parade truly begins. The lead parade group is preceded by the Yeondeunghoe flags, followed by the flags of Inrowang Bodhisattva (the Benevolent Kings) and Obangbul (the Five Directions of the Buddha: four cardinal directions and the center). These are followed by the traditional royal music ensemble and the honor guard, forming the lead group. You may reference the Lantern Parade diagram for the order and flow of the different lanterns.

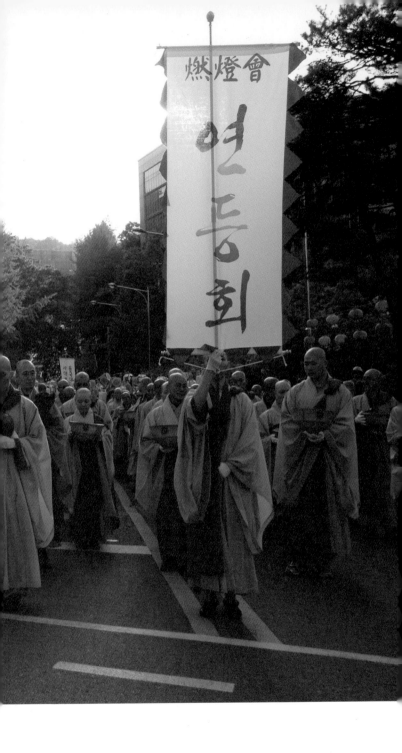

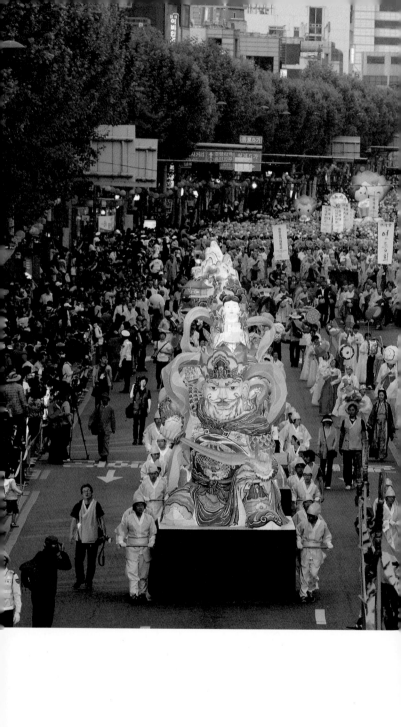

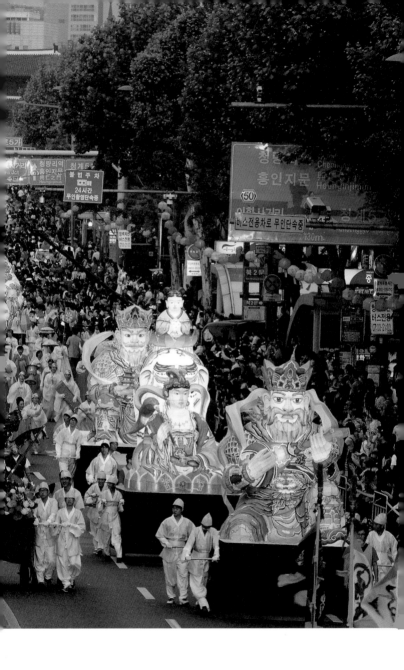

Lantern Parade: A River of Light

The Lotus Lantern Festival is a traditional celebration with 1,300 years of history in Korea and is held just before Buddha's Birthday. The parade participants fill the streets of Jong-ro with the beautiful lights of handmade lanterns. Tourists from all over the world gather to see the Lantern Parade which is held only one night of the year. The parade is the highlight of the Lantern Festival.

As the sun sets on the city, a river of lights begins to flow. Held annually on the Saturday before Buddha's Birthday (7:00~9:30 P.M.), the parade of beautiful grand lanterns and colorful hand-held lights is an unforgettable sight.

The streets of Jong-ro are teeming with people from early evening on, all gathered to see the parade that pulses through Dongdaemun, Jongmyo Park, Tapgol Park and Jogyesa Temple. Some people assume that the Lotus Lantern Festival refers to a parade of lanterns in the shape of lotus flowers symbolizing Buddhism, but the word *yeondeung* 燃燈 actually means "to light up or illuminate." *Yeondeunghoe* 燃燈會 refers to a gathering with illumination of lanterns. The Lotus Lantern Festival is a festival of lights in all shapes and sizes, radiating from the grand and small parade lanterns.

The parade is led by the Yeondeunghoe flags, with the Baby Buddha on the *gwanbul* platform at the head, followed by various traditional lanterns. As the commanding presence of the grand lanterns flows through the streets with the theatrical troupes in tow, tens of thousands of parade lanterns, each in unique color and shape, merge into a sea of lights. People enamored with the beautiful hues of the lanterns cheer, as cameras flash to capture the moment forever.

The Lantern Parade is not simply a parade of lanterns. Each individually crafted lantern embodies the maker's hopes for happiness along with that of his or her neighbors. Therein lies the traditional culture of Korea. The Yeondeunghoe was designated Important Intangible Cultural Asset No.122 in 2012. The Lotus Lantern Festival grows with an emphasis on

its traditional roots. As a festival of 1,300 years history, there are continued efforts to revive the tradition and represent contemporary societal values.

With over 30,000 attendees each year, the Lotus Lantern Festival has grown into an international celebration with a Buddhist history. A guide to the Lotus Lantern Festival is now published in seven languages; it is the only festival in Seoul on which foreign visitors have requested additional information. At the intersection of Tapgol Park are extra stands for foreign visitors, with commentators guiding in four languages (Chinese, English, Japanese, Korean).

*

Lantern Parade

• Time
Saturday 7:00-9:30 P.M.

• Place
Dongguk University, Dongdaemun – Jongmyo Park – Tapgol Park – Jogyesa Temple

• Transportation
Subway Lines 1, 3, 5 to Jong-ro 3-ga Station/ Line 1 to Jonggak Station or Jong-ro 5-ga Station

*

Watching the Lantern Parade

Stands with multi-lingual commentators (Chinese, English, Japanese, Korean)
There are extra stands on either side of the street at the Tapgol Park intersection along the parade route.
If you wish to be comfortably seated for the three-hour parade, you may want to reserve your seats twelve hours ahead

The post-parade celebration (Hoehyang Hanmadang) begins soon after the parade. You want to keep your energy up for this! Remember to have a good healthy meal before the parade and bring snacks.

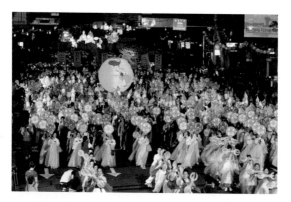

In the Buddhist community, the lighting of a lantern is a prayer to receive the Buddha's teaching of wisdom, as well as a practice of compassion for the benefit and joy of all sentient beings. The world becomes brighter with the lighting of each lantern.

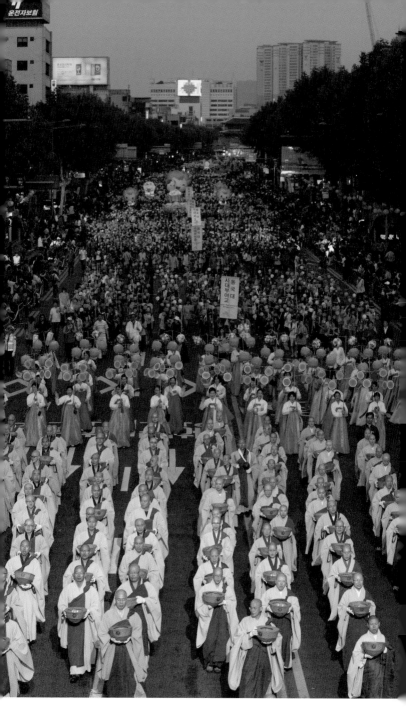

The Lotus Lantern Festival is especially a celebration of all Buddhist practitioners and laypeople. On this day, Buddhist monks are seen holding lanterns in the shape of a *patra* (alms bowl) in an expression of humility and solemnity.

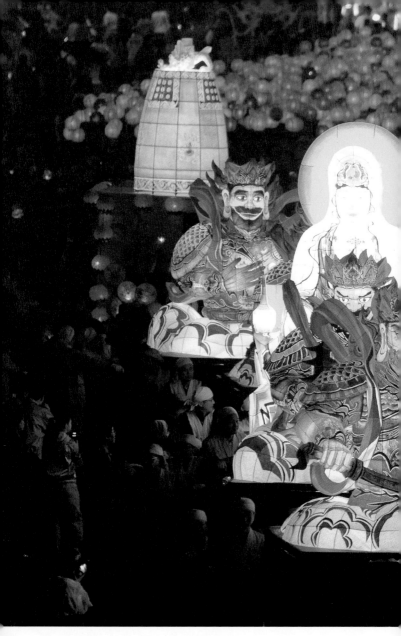

Unity is an essential element of the grand lanterns as they bring people together to create something from nothing. The making of a grand lantern is a practice in consideration and communication.

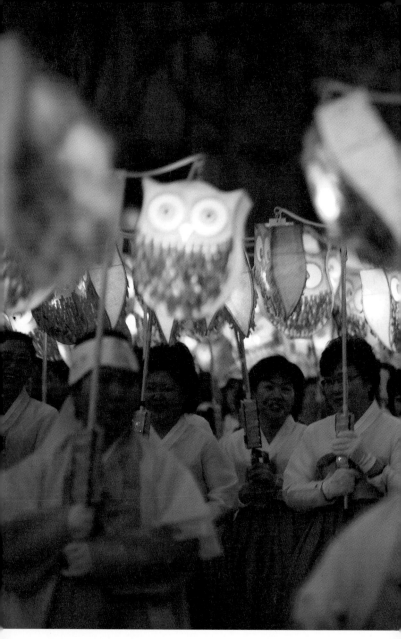

Small parade lanterns add an element of charm to the Lantern Parade. Unlike the exhibits of stationary lanterns, these lanterns are made to move in the parade with each participant. The parade lanterns move, perform and express.

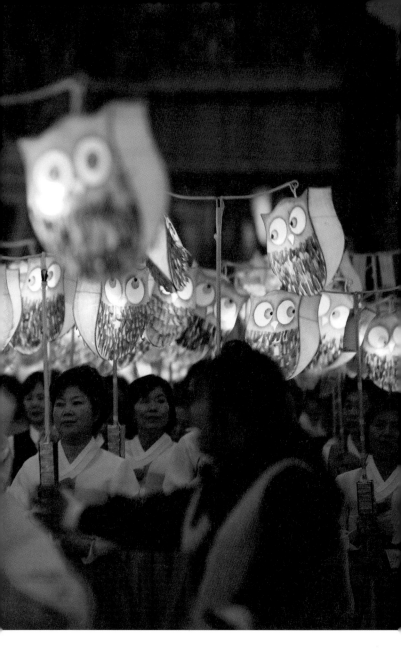

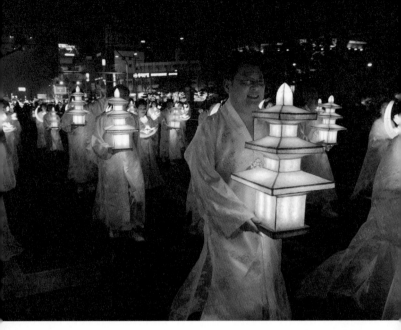

The lanterns light up in unique hues. Some lanterns are lit with candles, while others use LED lights. The color and shape of each lantern in the parade is unique.

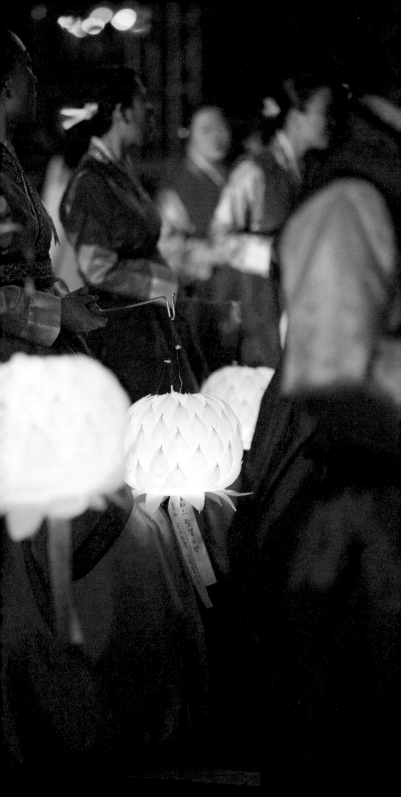

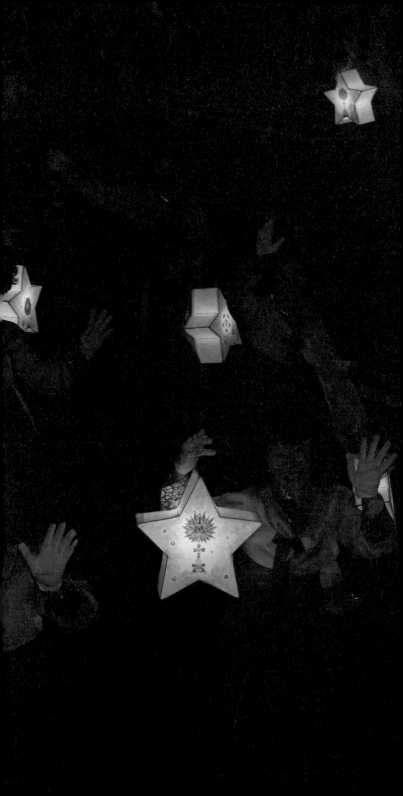

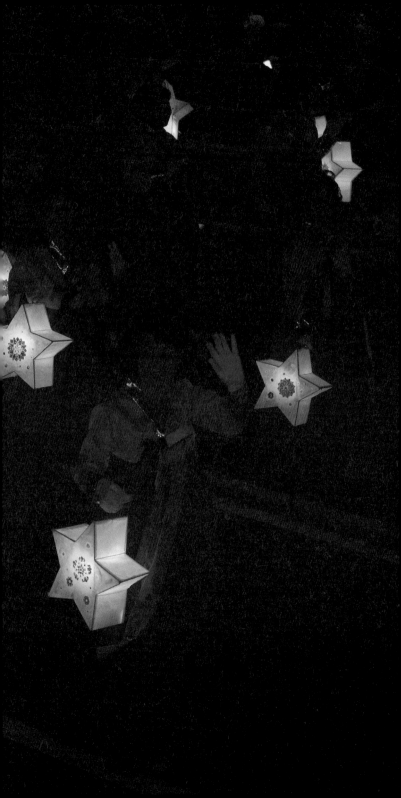

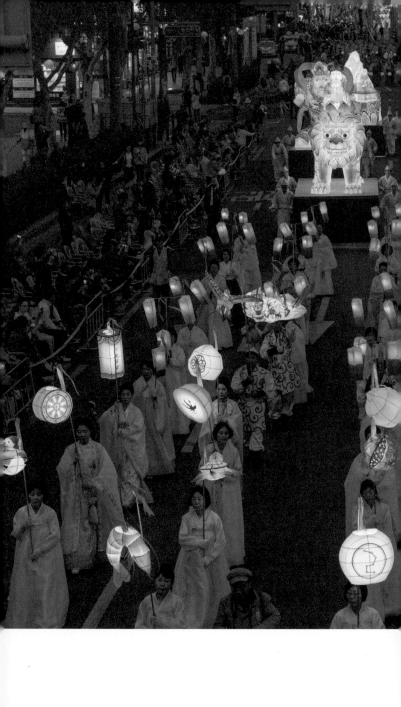

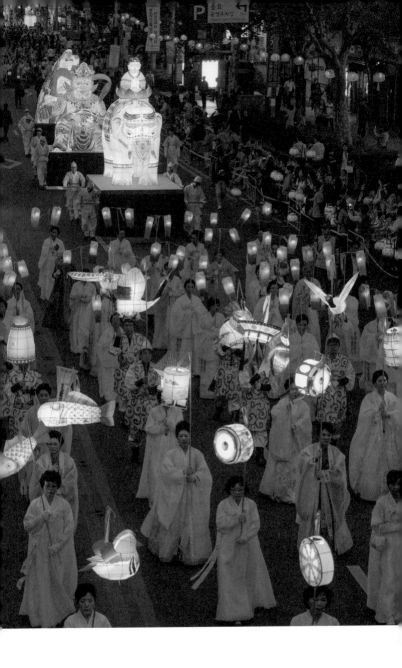

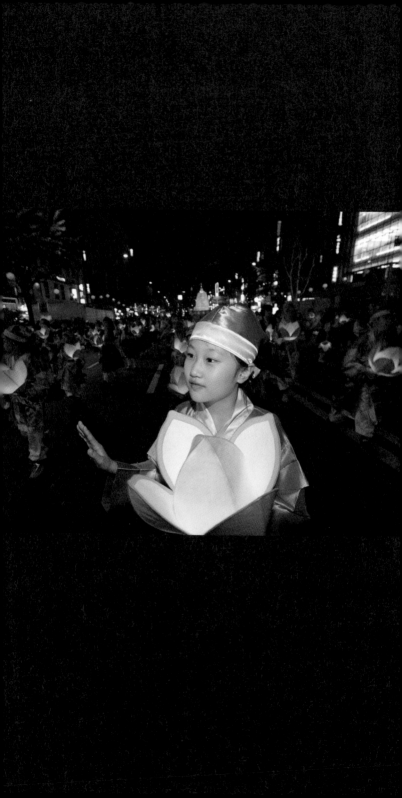

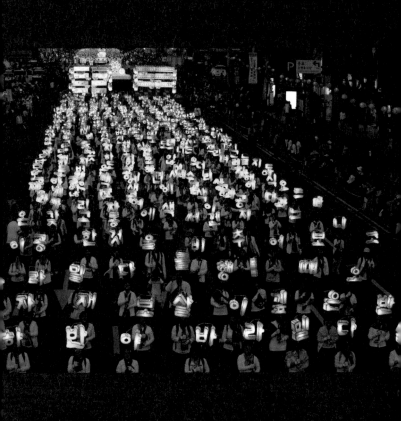

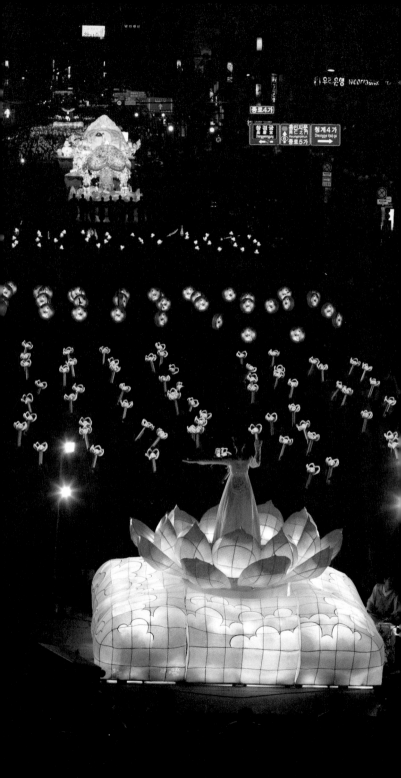

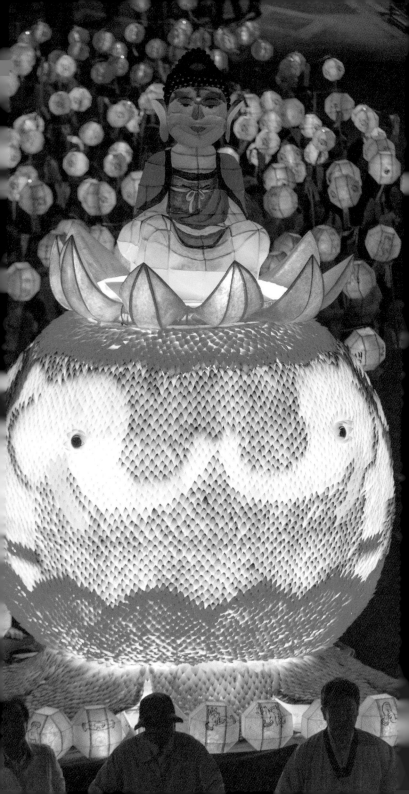

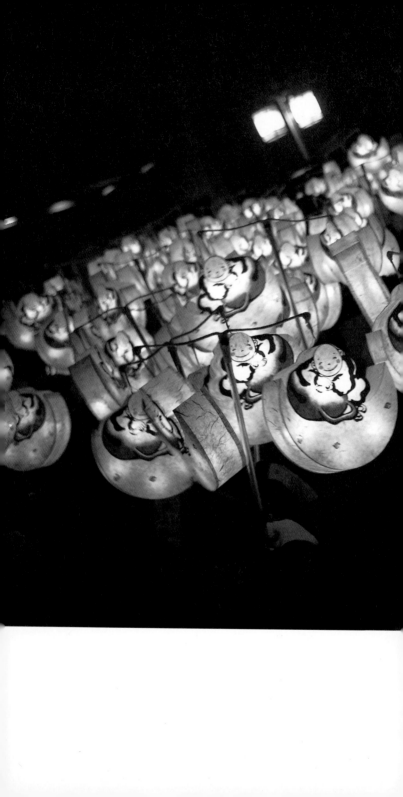

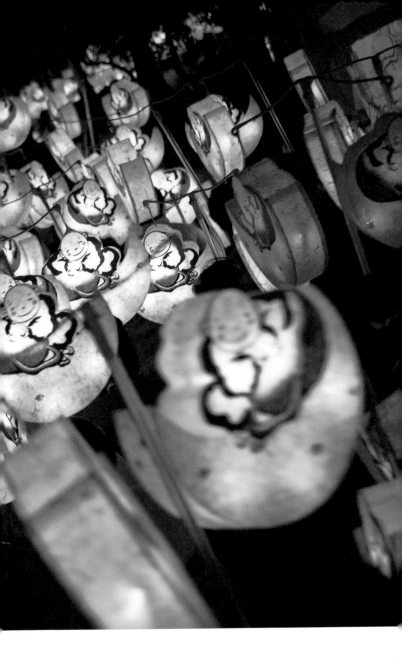

Origin of the Lotus Lantern Festival: The Light of a Poor Woman

The Lotus Lantern Festival originated with the tradition of offering lanterns to the Buddha. The offering is a prayer to illuminate the ignorance of greed and anger through the light of Buddha's wisdom. Lantern offerings have existed since the time of Buddha. There is a tale of "The Single Lamp of a Poor Person (貧者一燈)" in the *Sutra of the Wise and Foolish* (*Damamuka Sutra*).

One day the Buddha came to stay in a village. At the news of the Buddha's visit, everyone, including the king, lit lanterns in a show of praise and welcome. Aniruddha, who lived in extreme poverty from one meal to next, could do nothing for the Buddha's visit. She sat in lament and apprehension, thinking, "Without good deeds in my past life, I haven't a thing to offer the Buddha."

Hoping for the opportunity to accrue good karma, Aniruddha went to purchase lamp oil with two coins, her full day's pay. Although not enough for oil, the storekeeper listened to her story and gave her more than two coin's worth. Making a lantern from a simple can and wick, she lit the lantern and prayed:

"Enlightened One, I have nothing. Here I light this lamp with all I have, all my heart. I here offer respect to the Buddha's infinite wisdom. I pray I may enter nirvana in the next life."

Then a strange thing happened. As all the lanterns slowly burned out one by one through the night, Aniruddha's lamp remained lit. The lamp burned ever brighter as people attempted to blow it out. Witnessing this, the Buddha spoke:

"You will not blow out the light. All the waters of the sea will not extinguish the light of a poor woman, who has lit it with the fuel of her heart."

The Buddha then told Aniruddha that she would achieve Buddhahood. This story tells of the virtue that shines forth from a heart of goodness.

Just as the poor woman in the story, each participant of the Lotus Lantern Festival creates a lantern of one's wishes. It is a light for oneself, one's family, one's neighbors and the nation. What burns brightest at the Lotus Lantern Festival is the light of a wish for happiness.

Yeondeunghoe: Important Intangible Cultural Asset No.122

The Lotus Lantern Festival is a traditional festival full of Korean history and culture. It is a living cultural heritage with over 1,000 years of history, not a stationary artifact in a museum. In recognition of its significance, Yeondeunghoe was designated Korean Important Intangible Cultural Asset No.122 in April of 2012. More than simply a Buddhist religious ceremony, it is a cultural heritage that all should cherish and take pride in.

The festival as a cultural asset is demonstrated in many elements. The lantern parade is a recreation of the king's honor guard parade in the lantern parades of the Goryeo period. For the parade, people create their own lanterns imbued with their hopes and dreams. The lantern crafting methods also employ traditional crafts. Natural dyes made from spinach and gardenia seeds are used to give subtle hues to *hanji* paper, the traditional lantern covering. The beauty of traditional designs referenced in literature has also been recreated. People parading in colorful traditional and contemporary *hanbok* attest to the efforts in continuing the festival's tradition.

중요무형문화재 제122호
연등회
Yeon Deung Hoe　燃燈會

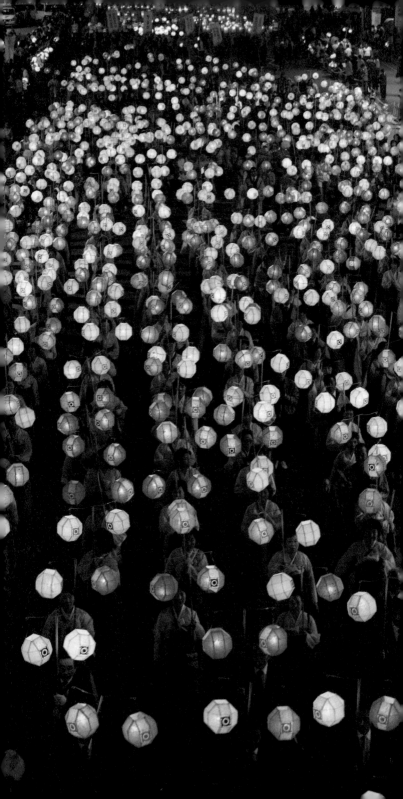

As with *seol-bim* (New Year's dress) and *chuseok-bim* (Thanksgiving Day dress), there was once a tradition of preparing new *chopail-bim* (Buddha's Birthday dress). Although not requiring new attire for every Lotus Lantern Festival, donning *hanbok* for the parade is encouraged. Other traditional elements of the festival are the Gwanbul Ceremony (bathing of the Baby Buddha), the Hoehyang Hanmadang celebration (a modern variation on the *daedong nori* tradition) and the Folk Games Madang to revive the *baekhi-jabgi* tradition of Goryeo.

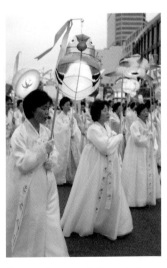

The parade of people in *hanbok* moving to the beat of *pungmul* (traditional Korean percussion band) recreates the Lotus Lantern Festival tradition of old. Each year the festival comes alive anew, and the tradition continues.

The Lotus Lantern Festival is a Celebration: A Festival of Joy for All

Some may expect a Buddhist ceremony to be calm and quiet. The Lotus Lantern Festival is a celebratory occasion of energy and splendor. From its historical roots to now, the festival has been led by young people. As the lanterns are created and carried by the young, the Lotus Lantern Festival has come to be a celebration of dynamic energy.

The festival is proud of its dynamic volunteer participants, as each and every person plays an important role. Not pressured by anyone, each participant contributes their own time and energy to make the festival possible. People volunteer for the theatrical troupes and the making of parade lanterns. As the festival they have long awaited and prepared for approaches, all participants are overflowing with energy. Then the dynamic festival begins with great vigor.

Participants waste no time in letting their imagination soar for next year's lantern design, even as this year's festival is wrapping up. The craftsmanship in each lantern often reaches the level of professional artisans.

There are many lanterns designs based on items mentioned in the teachings of the Buddha such as the Buddhist symbols of the elephant and the lotus. There are also designs representative of each temple and organization. Some lantern designs are also taken from daily life.

The theme for a lantern might be anything and any material can be used. Materials might even include

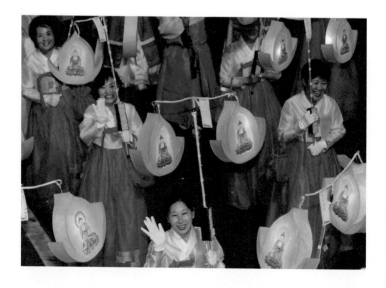

shopping bags hoarded by thrifty housewives, and themes can come from the 438 Korean characters of the *Heart Sutra*, the national flag of an expatriate monk or a soccer ball representing the Korean soccer team.

Each participant in the Lantern Parade is a producer of the show, planning and directing the festival. The Lotus Lantern Festival has continued to develop with everyone's voluntary participation. One device that has improved the festival is the new T-shaped lantern holder, where two lights are hung on each arm of the T, over the ㄱshaped design where only one lantern could be hung. At the festival, each participant is a producer, a star and a fan. Designed by a festival participant, the T-shaped lantern holder now makes the Lotus Lantern Festival twice as bright. It is amazing that both the original ㄱ and the new T design were the ideas of festival participants.

It is the experience of walking in the parade that inspired both designs. The collective spirit of all the participants in the Lantern Parade, in their efforts to revive and further develop the tradition, has made the festival an occasion where global citizens can come together in joy. Here people can sense that their own joy is shared by others. It is the festival participants' efforts to create a festival they themselves enjoy, a festival full of fun, that have made the Lotus Lantern Festival what it is today.

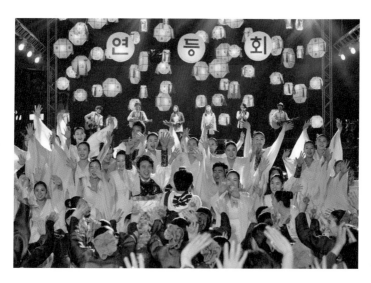

The Lotus Lantern Festival is about Sharing: Sharing Both the Happy and Sad Times, an Occasion for Hope

The Lotus Lantern Festival has been with us for over 1,000 years. It is an occasion for people to share their joy in times of happiness. It is an occasion for people to come together and work through the challenges in times of difficulty. This is possible because the festival is not simply an event arranged by a hosting committee; it is a communicative festival for everyone. During Korea's 1998 financial crisis, when many were down and frustrated, the Lotus Lantern Festival served to bring people together. As the IMF crisis loomed in late 1997, the Lotus Lantern Committee put together a large-scale candle ceremony to pray for those in despair. Along the six-lane road in front of Jogyesa Temple, the words "Let's Rise Again" were spelled out in candlelight, and the media coverage helped create an atmosphere of hope. The event was one more occasion that emphasized the importance of the Lotus Lantern Festival.

In 2014, the sinking of the Sewol Ferry left the country in deep shock and despair, occurring just ten days before the Lotus Lantern Festival. The Yeondeunghoe

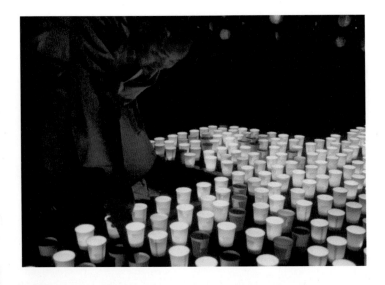

Preservation Committee, along with 200 other organizations, met to rewrite the theme of the festival to "Together in Sadness, Gathering Hope" to commemorate the dead and missing. In place of the spectacular grand parade lanterns were 100 elegies for the dead, small lanterns in white and red and yellow ribbons in prayer for the safe return of the missing. The Lotus Lantern Festival is Korea's cultural heritage, where people come together in both happy and sad times, a festival of *han* and *heung* (heartache and joy).

*
The Lotus Lantern Festival 2014, a Commemorative for the Nation
The commemoration for those who died in the Sewol Ferry disaster continued throughout the day of the parade into the Cultural Events the next day. The Buddha's Birthday often has clear weather, but that day, it rained off and on.

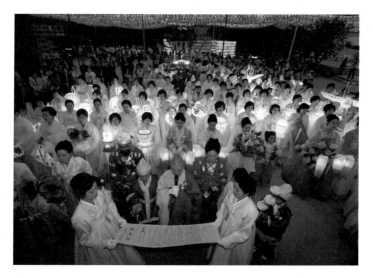

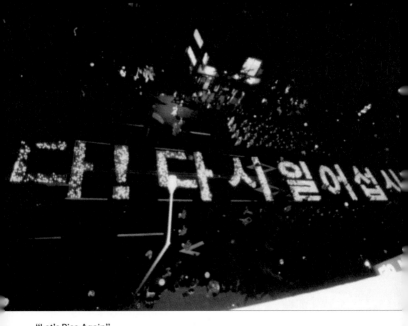

"Let's Rise Again"
These were the words spelled out in candlelight for the Lotus Lantern Festival. It helped to cheer people up in the financial crisis of 1998.

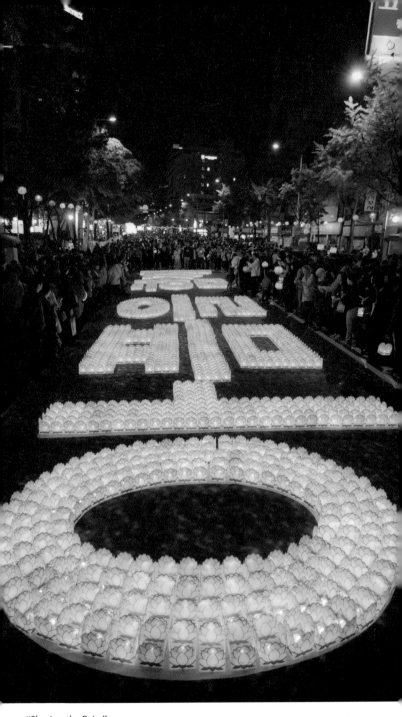

"Sharing the Pain."
The Lotus Lantern Festival of 2014 was an occasion to reflect on ourselves and our society, an occasion to rethink the meaning of the word "collective."

_ FAQs about the Lotus Lantern Festival!

Q _ Who moves floats for the Lantern Parade? And how?
A _ The creation of the lotus lanterns and transporting them to the parade site are all done by ordinary citizens. Small parade lanterns are brought in by their owners on the day of the procession, and large grand lanterns are transported to Dongdaemun the day before. Volunteers bring them in from Buddhist temples both near and far by truck or by car.

Q _ Does the Lantern Parade follow the same course every year?
A _ The route of the Lantern Parade has changed over time. Starting in 1976 the festival was relocated to Yeouido Square, and the parade followed an 11 km route from Yeouido Square, through Gwanghwamun and Jongak, and ended at Jogyesa. The course changed again in 1996 with the Lantern Parade starting at Dongdaemun Stadium, passing through Jong-ro and arriving at Jogyesa. With the demolition of Dongdaemun Stadium in 2008, the route was changed again. The float lanterns now leave both Dongdaemun History and Culture Park and Dongguk University. The processions meet up in the vicinity of Heunginjimun Gate and proceed through Jongmyo and Tapgol Park before arriving in front of Jogyesa Temple.

Q _ Is there a procedure for watching the Lantern Parade?
A _ There is no special procedure for watching the parade. You may find it fun to note the individual costumes and lanterns as the parade passes.

Q _ Can I find a way to make a lotus lantern myself?
A _ Before the Lantern Parade, lantern-making is in full swing at all Buddhist temples. If you have an interest in trying to make a lantern, you can inquire at a local Buddhist temple. The day after the Lantern Parade, you can also try your hand at making a lantern using paper cups at the Traditional Cultural Events Madang.

Q _ Are the lanterns in the Lantern Parade used only once and discarded?
A _ It is not common for lanterns in the parade to be used again the following year. There is the possibility of damage during the procession, and after a year the colors will begin to fade. The lantern frames may be reused with new paper and decorations. The labor-intensive float lanterns are sometimes reused the following year, or they may be sent to other regions to promote the Lotus Lantern Festival.

Hoehyang Hanmadang: The Post-Parade Celebration Raining Flower Petals from the Night Sky

The excitement of the Lantern Parade continues at the Hoehyang Hanmadang, Post-Parade Celebration, at Jonggak intersection. The lead group in the parade holds a memorial service at Jogyesa Temple. Following the lead group, the traditional lanterns with the honor guard and the Baby Buddha at the head, circumambulate the pagoda. The excitement of the Lotus Lantern Festival spills into the courtyard of Jogyesa Temple, alight with a multitude of colors. It is transformed into a small festive arena of its own. The Grande Lanterns that lit up the parade are then moved from Jonggak intersection to the street in front of Jogyesa. Here you can get a closer look at the lanterns that fascinate you.

Now it is time to get your bodies moving! The Hoehyang Hanmadang is the final celebration of the Lantern Parade, a time for collective fun in the tradition of *daedong nori*. *Daedong* 大同 means it is time for everyone to come together without regard to age, nationality, gender or religion.

On stage, traditional performers and artists perform the Lotus Lantern Festival theme song, along with the theatrical troupes. People crowd the stage and dance to the rhythm of the *ganggangsullae*, encouraging each other to forget their worries and have fun. Holding the hand of someone you just met, dancing in a conga line and high-fiving strangers is not an everyday sight in Seoul. Add to that a plaza full of foreigners and you have a unique, one-night-a-year experience. As the Hoehyang Hanmadang celebration reaches its peak, a shower of pink flower petals falls from the sky, transporting you to another world. It is said you will have a year of good fortune if you see this rain of flowers. A fun-filled experience and a year of good fortune; who can resist? Nights at the Lotus Lantern Festival are more exciting and beautiful than the daytime.

Jonggak intersection, where the Hoehyang Hanmadang Post-Parade Celebration takes place, becomes a small global community; and the international language here is the *ganggangsullae* dance! Laughing and dancing altogether, words are not necessary to make friends.

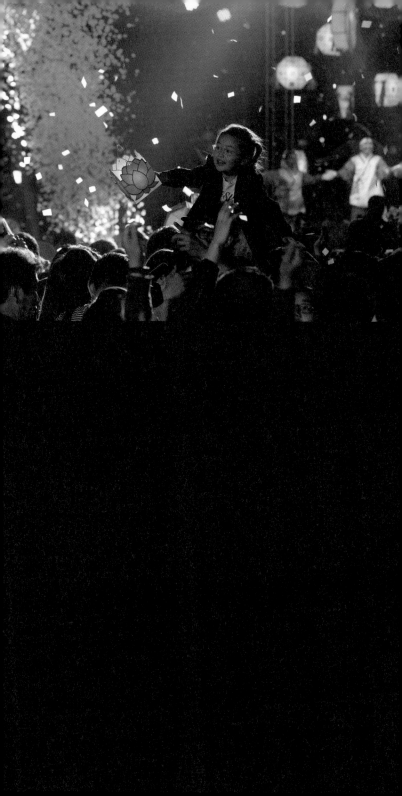

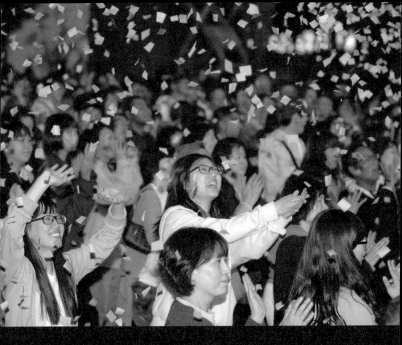

*
**Hoehyang Hanmadang: The Post-Parade Celebration
with Flower Rain**
• **Time**
Saturday 9:30-11:00 P.M. (After the Lantern Parade)
• **Place**
Jonggak Intersection, in front of Bosingak Pavilion
• **Transportation**
Subway Line 1 to Jonggak Station

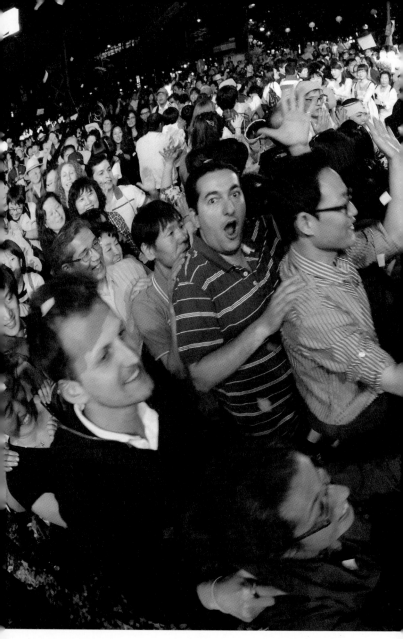

Each and every participant is a hero at the Hoehyang Hanmadang. Don't be surprised to find yourself at the head of a conga line and pulling in innocent bystanders. Each year the Hoehyang Hanmadang is a whole new celebration, with a plaza full of new faces creating a unique event.

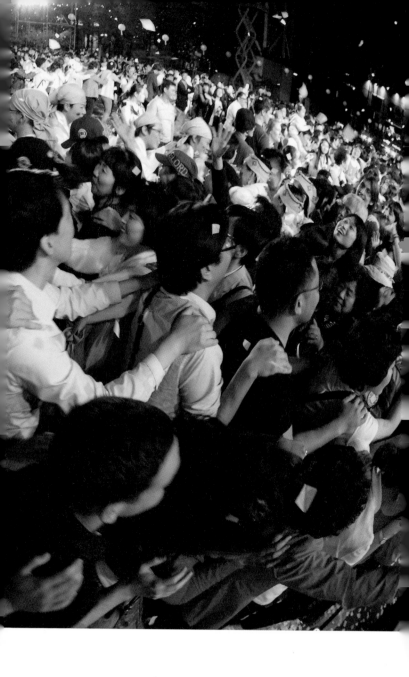

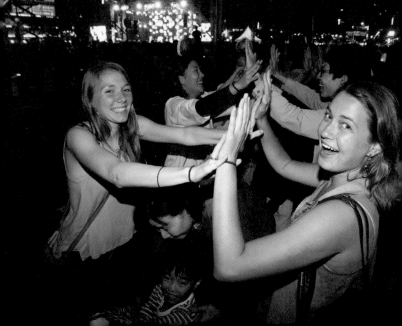

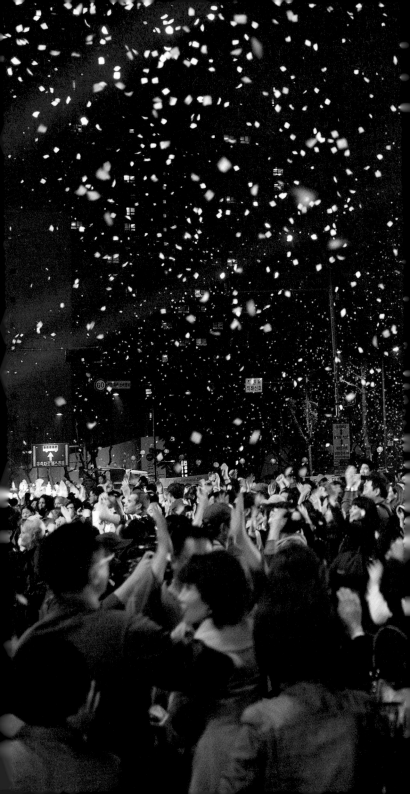

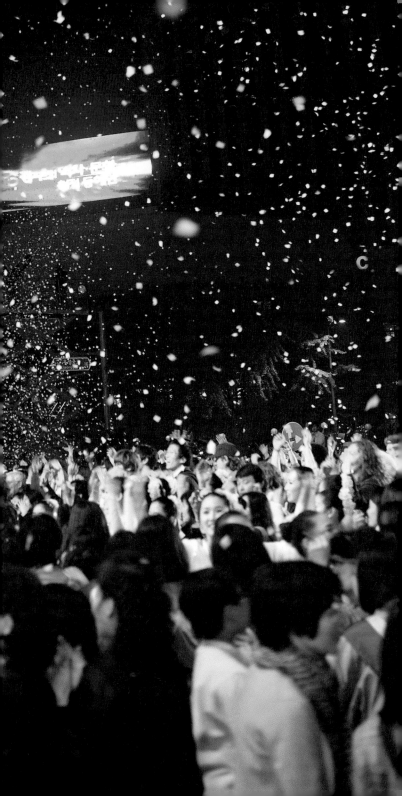

3 Festival of Joy and Laughter

Traditional Cultural Events:
Jeontong Munhwa Madang

One element that may be contributing to the growth of the Lantern Festival into a popular international festival is the "fun factor." Everyone, whether Buddhist or not, can join in the festival. The Lotus Lantern Festival is full of things to do and see, things you cannot experience anywhere else. At these events, you meet people from all over the world. On the day after the Lantern Parade, along the streets of Jong-ro, the Traditional Cultural Events are held offering something for everyone.

The events are unique in that one can experience firsthand Korean and Buddhist cultural traditions. It is as popular as the Lantern Parade and has an increasing number of visitors every year.

The events are held on Sunday from noon to 7 P.M. (last day of the Lotus Lantern Festival) in front of Jogyesa Temple. The wide multi-lane streets, normally full of traffic, transform into a large plaza with over 100 booths. The occasion resembles an outdoor market full of people. Most of the programs are designed to be experiential, with things to see, play and eat. Many at the events are families and foreign visitors.

The Traditional Cultural Events started under the moniker of Street Festival in 1996. In the beginning, this part of the festival mostly consisted of lessons in making lanterns from paper cups and the sale of Buddhist goods and articles. Since 1998, with its growing popularity, it has evolved into more of a "cultural sharing" event. This venue for cultural events has played an important role in the development of the Lotus Lantern Festival into a celebration of the folk and traditional culture of Korea.

The Traditional Cultural Events has two main areas, where you can see and taste traditional Korean and Buddhist culture. At the Performance Madang, you can enjoy theatrical

performances in the tradition of *baekhi-japgi*, historically performed following the lantern parade in the Goryeo period. You can also participate in traditional Korean games, as well as experience the Buddhist cultures of Korea and its neighboring Asian nations.

With different organizations and programs participating every year, the Traditional Cultural Events Madang is unique each year. The events exclude commercial elements, being a place to experience and share in aspects of often overlooked traditional Buddhist and Korean culture. All events are free of charge, with a minimal fee for materials when necessary. All you need to bring are your plans for fun!

*
Traditional Cultural Events

• **Time**
Sunday Noon – 7 P.M.
(last day of the Lotus Lantern Festival)

• **Place**
Street in front of Jogyesa Temple

• **Transportation**
Subway Line 1 to Jonggak Station
Subway Line 3 to Anguk Station

Traditional Cultural Events

Lotus Lantern Making for Foreigners

Together with partners, family and friends, foreign participants at the lantern making event enthusiastically make lotus lanterns, joyfully saving the memory in photographs. Making beautiful lotus lanterns on your own is a great feeling, and you may even receive a prize. The best part of the event is being able to take your creation home with you.

Performances

Here is where you can watch a traditional Buddhist monastic dance, crane dance, the Yeongsanjae Buddhist Ritual (celebration of Buddha's sermon on Vulture Peak), tightrope walking and other such traditional Korean performances, as well as traditional performances from Tibet, Mongolia, Thailand and other Asian countries. With performances happening nonstop from noon until 6 P.M., you will hardly be able to take your eyes off the excitement for a moment.

Temple and Healing Madang

Experience Buddhism by being led in the practice of 108 Bows by a Buddhist monk and receiving guidance in Seon meditation. While sitting calmly in the lotus position with eyes closed, you will feel as if you are deep within a Buddhist temple.

Gwanbul Ceremony

In this ritual of pouring water (*gamro-su*) on the head of the Buddha, you also purify your own body and soul, and pledge to live a pure and honest life. It is a formal and reverent ceremony.

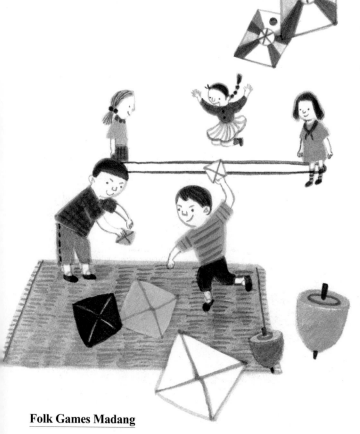

Folk Games Madang

Slap-match, top-spinning, jumping rope··· now seldom seen, these traditional games are perhaps more exciting for Korean parents than for their children. This is a time for children and parents to grow closer playing old-fashioned Korean games.

Traditions Madang

Experience making traditional Korean paper crafts, including masks and fans. You can also try on traditional Korean wedding clothes and indulge in other traditional Korean cultural activities. Although the majority of participants are foreigners, it is as meaningful for Koreans to participate and experience the traditional Korean culture.

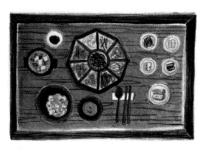

Food Madang

It is easy to spend almost all day looking around at the traditional cultural events. The Food Court is a welcome sight. After eating some steamed rice wrapped in lotus leaf, vegetarian *bibimbap* and other Buddhist temple foods, you can better take in the rest of the day's experience.

Buddhist Painting

Here is the opportunity to try your hand at the Buddhist painting you have often admired. In the flowing concentration of each brush stroke, you may begin to feel the wisdom and compassion of the Buddha.

NGO Madang and World Buddhism Madang

While exploring the activities of NGOs whose work it is to build a more inclusive society for everyone, you will recognize the power in your hands to help create a world of beauty.

At the World Buddhism Madang, you will learn about Buddhism in Asian countries including Thailand, Sri Lanka, Mongolia and Tibet and how they compare with Buddhism in Korea.

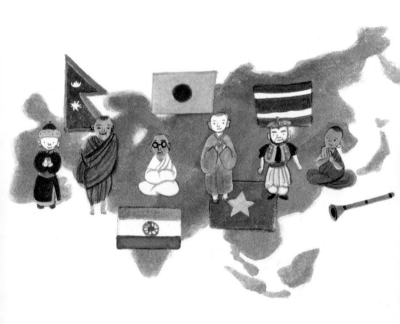

Sharing Madang

The *moktak* (wooden hand bell) embodies the Buddhist wisdom of mindfulness, to be awakened. Hearing the sound of the moktak while making paper lanterns or indulging in other activities designed for children, visitors can experience Buddhist culture with a joyful heart and grow more familiar with Buddhism.

Yeondeung Nori

This is the final event of the Lotus Lantern Festival where a procession of grand float lanterns and theatrical troupes proceed through Anguk-dong, Insa-dong and finally to Jogyesa Temple. Here the performance troupes and visitors to the festival come together in song and dance, remembering this year's experiences and looking forward to next year's festival.

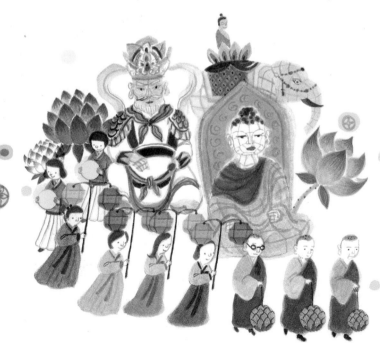

Lotus Lantern Making for Foreigners

One of the most popular programs at the Traditional Cultural Events is the lantern making competition for foreigners. For those hoping to recreate lanterns seen in the parade, the program has hundreds of registrants each year.

The program gathers around 400 participants who register through the International Dharma Instructors organization (World Fellowship of Buddhists) of the Jogye Order of Korean Buddhism. The program has two sessions: first session is from 11 A.M. to 2 P.M, and the second from 2 to 6 P.M. With the ever increasing number of interested foreign visitors, there is also a small booth that teaches those who could not register how to make a lantern from a paper cup. Some may get lucky and get a spot that opens up in the main class. Begun in 2000, the lantern competition for foreigners is a big hit. It has taken root as the most popular program for foreign visitors to the festival and is now the main event at the Traditional Cultural Events.

Here visitors learn to make the beloved Korean lotus lanterns, learning firsthand the effort involved in making them. The best lanterns are awarded prizes. It is an experiential program that builds upon what they have seen in the Lantern Parade. Here they participate in lantern making themselves and learn the meaning and workings of the Lotus Lantern Festival. Hundreds of foreign visitors in serious yet joyful concentration to make a lotus lantern grabs much attention from passersby. The booth is brimming with people all day, as Korean visitors like to join in with the foreign participants. The interesting part of the lantern making sessions are the varied hues and unique designs of the lanterns. Without any fixed idea of what a lotus flower looks like, the foreign visitors create lanterns unlike any other.

Foreign visitors make their own lotus lanterns, pasting each lotus petal onto the octagonal frames. The program has increased in size every year to accommodate the large number of those interested. Very popular, not all registrants can be guaranteed a spot.

*
Lotus Lantern Making for Foreigners

• **Time**
Sunday
11:00 A.M. - 2 P.M. (Session 1)
2:00 P.M. - 6 P.M. (Session 2)

• **Place**
The Street in front of Jogyesa Temple
Lotus Lantern Making for Foreigners Program
Preregistration required

• **Information**
International Dharma Instructors (World Fellowship of Buddhists)
The Jogye Order of Korean Buddhism
Phone _ 02 722 2206

There are also interpreters and an information center at this event, and so fluency in Korean is not necessary. There are other booths that teach how to make small lotus lanterns at the Traditional Cultural Events Events Madang. If you are not able to take part in the program, you can try one of those.

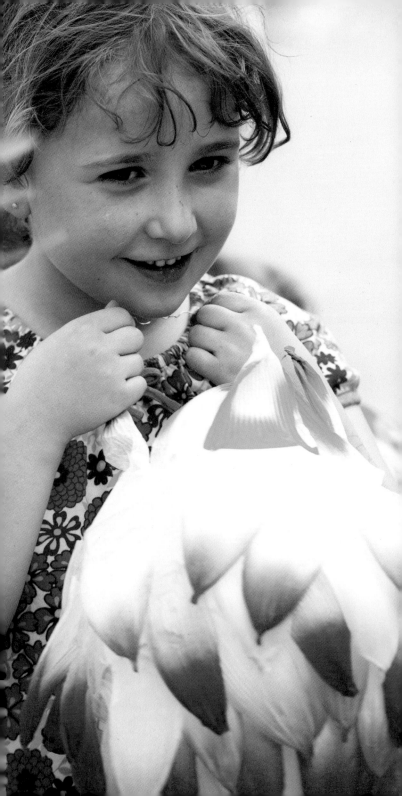

Cultural Performances Madang

At the stage set up for the Traditional Cultural Events Madang in front of Jogyesa Temple you can watch numerous live performances. The program opens with *gilnori* (street performances), and altogether there are over 17 hours of performances by various groups. The program varies year to year and usually includes such traditional Korean performances as: Bukcheong Sajanoreum (lion-mask dance), tightrope, *pungmul nori*, percussion performances, Yeongsanjae (celebration of Buddha's Sermon on Vulture Peak Mountain), *seungmu* (monastic dance) and Seonmudo (Korean Buddhist martial art). These are also traditional native performances by performers from other primarily Buddhist nations. The content and quality of the performances are high, and one could easily spend the whole day at the Performances Madang. You may want to note the times of the performances you want to catch, while you visit the different booths at the Traditional Cultural Events Madang.

*
Cultural Performances

• **Time**
Sunday _ 12 P.M. - 6 P.M.

• **Place**
The Performance Stage, in front of Jogyesa Temple

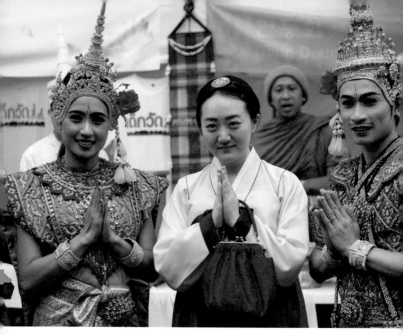

The Cultural Performances Madang is modeled after the *baekhi-japgi* performances that followed the lantern festival during the Goryeo period. Folk and traditional performances of song and dance, music and tightrope walking, along with various Buddhist performances, are held for the public. Also in the program are traditional performances from other Asian Buddhist countries.

Temple and Healing Madang

One of the most popular experiences for both foreigners and Koreans is the Jogye Order's Templestay program. Many people dream of a stay in a tranquil mountain temple, an opportunity not easy to come by, except in Korea. If you find Buddhism too foreign and difficult to understand, the Temple Madang may be a good place to visit. It provides information about the Templestay program, Buddhist culture and various Buddhist practices, including: Seon meditation and contemplation under the guidance of a *sunim* (Buddhist monastic), yoga, 108 Bows, *baru-gongyang* (monastic meal ceremony) and dancheong art (traditional Buddhist multi-colored decorative designs). With the growing international interest in Seon meditation, the number of Templestay participants is steadily increasing. The meditation and contemplation practices learned can be applied in daily life.

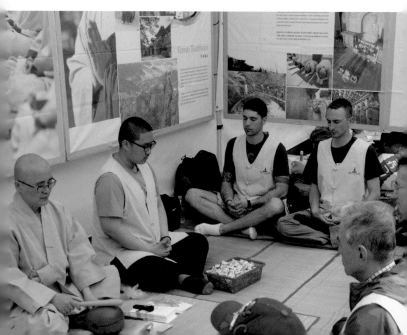

A Templestay in a city temple is a unique experience. Even in the midst of a crowd, one can still get a taste of the essence of a mountain temple when in meditative concentration with a *seunim*.

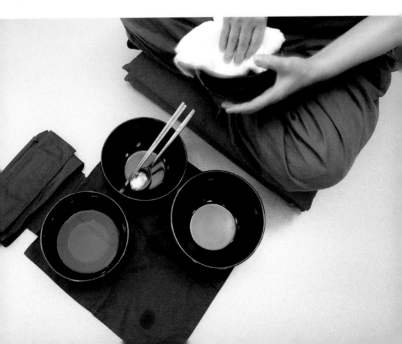

Foreign visitors to the Lotus Lantern Festival are able to experience traditional Korean culture in what is essentially a Buddhist celebration.
The festival is meant to be an occasion where traditional Korean and Buddhist culture and traditions come together.

Gwanbul Ceremony

Gwanbul is the ceremony of bathing the Baby Buddha and is performed in all temples on the Buddha's Birthday. An image of the Baby Buddha is placed on a Buddhist altar amid beautifully scented flowers and clear *cheongjeong-su* water is sprinkled on the crown of the head. The ceremony celebrates the birth of the Buddha, and is also a symbolic act of cleansing oneself to lead a good life.

It takes place before the Traditional Cultural Events and is preceded by the Yiun Service in Insa-dong, where the Baby Buddha is welcomed. The Gwanbul Ceremony takes place after the thirty-minute long Yiun Service, at which time the Baby Buddha is placed on the altar. An important part of the Buddha's Birthday celebration, the Gwanbul Ceremony is especially interesting to foreigners who have never seen it.

*
Yiun Service
Sunday _ 11:30 A.M. - Noon (Insa-dong)

Gwanbul Ceremony
Sunday _ Noon – 5:00 P.M. (Gwanbul Platform)

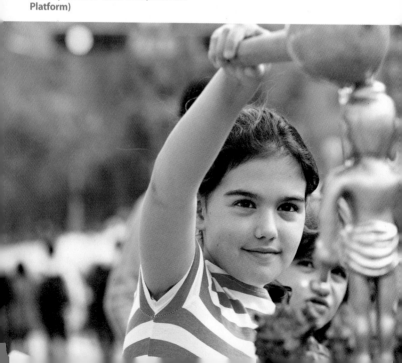

The *gwanbul* ceremony originated in ancient India. It is said that cleansing a likeness of the Buddha also washes away one's own sins and anguish, enabling one to lead a clean life and have good fortune.

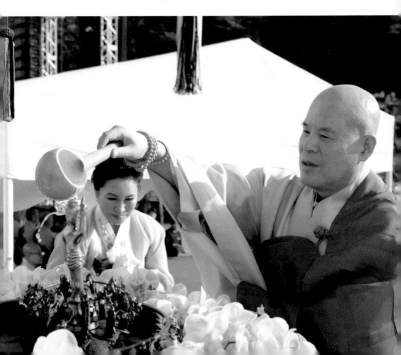

Traditions Madang

The Traditions Madang features programs that let visitors see and make for themselves many elements of traditional Korean culture not easily experienced today. Many families come with children for the novel experience. Some of the booths at the Madang offer: trying on *hanbok* for foreign visitors, paper lotus flower making, transcribing a sutra in gold ink (a practice from Goryeo period), lotus fan making (painting lotus flowers on a white hand-held fan), making lotus lanterns from paper cups, *gahun* calligraphy (writing of family precepts), *dancheong* painting (traditional multi-colored designs), making a good-fortune bag, making dolls from mulberry paper and traditional mask and the Taegukgi (the Korean Flag) making.

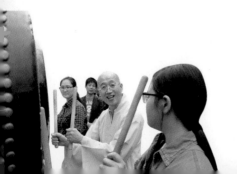

The Traditions Madang is as popular with Korean visitors as it is foreigner visitors. It is a place to experience traditional Korean culture usually only seen in books. The experiential programs are educational for children.

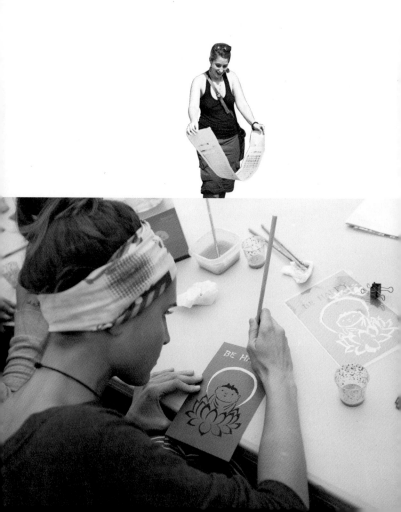

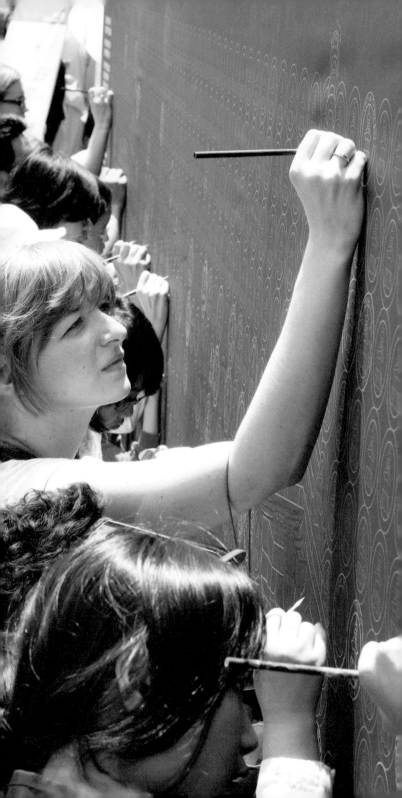

The Lotus Lantern Festival programs generally fall into three categories: performance, exhibition and experiential. Visitors may choose programs according to their interests. The programs where people can participate, make and enjoy things themselves are the most popular and highly rated.

Folk Games Madang

A *madang* is where you play! It is time to run around and play at the Folk Games Madang. Before computers and electronic games, kids were constantly moving their bodies and playing. The Folk Games Madang brings back traditional Korean games: *gomujul nori* (elastic band jumping) for girls, boys' games of slap-match and shuttlecock, marbles, diabolo, see-sawing, skipping rope and *tuho nori* (canister stick-throwing). The place is full of kids and adults laughing and having fun. For grownups, the Folk Games Madang brings back childhood memories. For children and foreign visitors, these never-before-played games are amazingly fun. The Folk Games Madang is full of fun for families and children.

The Folk Games Madang demonstrates that even simple toys can be great fun. Foreign visitors enjoy playing traditional Korean games for the first time, and Korean visitors enjoy sharing in their memories and experiences.

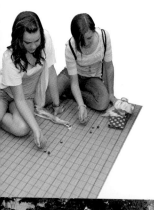

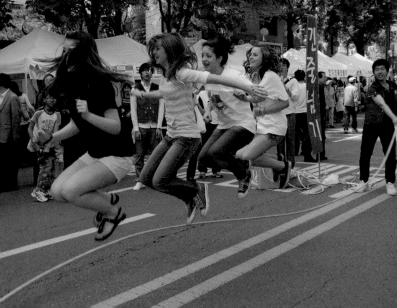

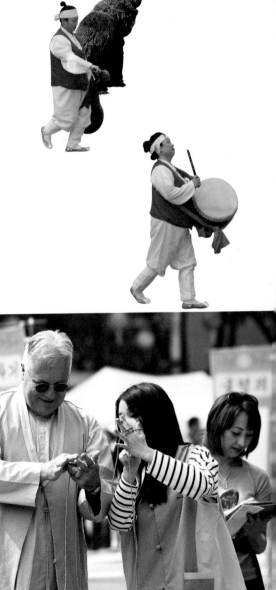

Food Madang

Delicious food is an essential part of every festival. Your nose will tell you the Food Madang is nearby even as you walk through the Traditional Cultural Events. Here is where you can try out temple food, an interesting experience in the middle of a big city. Well-presented and light on the stomach, the temple version of *jajangmyeon* (noodles in black bean sauce) and dumplings is highly recommended. You can also taste popular temple dishes of vegetarian bibimbap, along with traditional foods like *injeolmi* (rice cake). You can also learn to roll your own *gimbap* (rice and seaweed roll with seasoned stuffing). Here you can taste the temple foods you always wanted to try and pick up some temple food recipes. For dessert, try wonderfully aromatic lotus tea instead of coffee. It will enhance and complete your temple food experience.

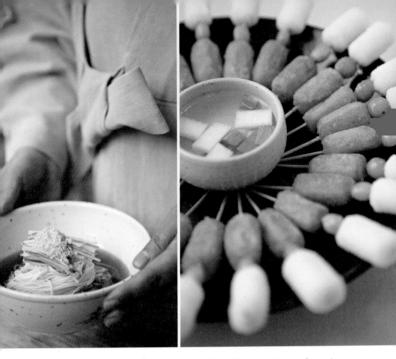

Temple food (*jeolbap*) is considered a part of Buddhist practice and requires discipline from the time it is prepared to when it is eaten. It is food to enhance diligent meditative practice and the realization of wisdom. Savor the temple food as you reflect on its true meaning.

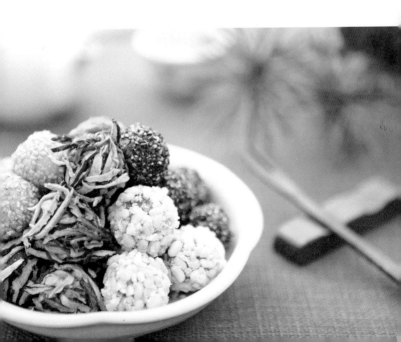

Sharing Madang

The Sharing Madang is a place to experience Buddhism through play, somewhat different than the Temple and Healing Madang of specialized Buddhist practice. Here the booths are run by various Buddhist associations. Visitors can: play a *moktak* (wooden Buddhist percussion instrument), attend a "Children's Dharma Service," make a drawing of the Buddha, make *danju* prayer beads, practice Sunmudo and make paper models of stone lanterns.

NGO Madang

The NGO Madang provides an opportunity to learn the practice of compassion through the Buddhist concept of *jatabuli* (the non-duality of "I" and "not-I"). These booths are overseen by Korean and international NGOs, whose work it is to aid those marginalized by society. They also support and promote environmental causes. These programs are designed to be fun and educational. Here you may learn through experience what it means to have a disability, make pressed flower handicrafts with the disabled, learn about the "zero garbage movement," make decorative wooden lotus flowers, read enlightening Buddhist literature, make ink-rubbings, make traditional paper painting and participate in support events for children in developing nations. There are also free clinics run by volunteer medical services, free dental exams and clinics about traditional Asian medicine. Sharing is both material as well as emotional.

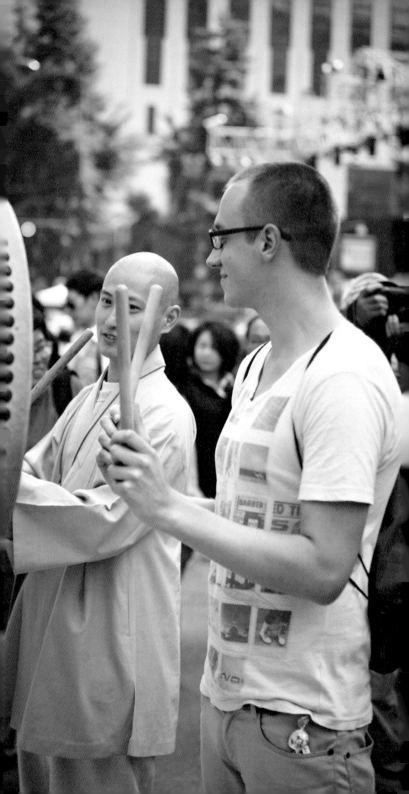

World Buddhism Madang

The World Buddhism Madang is a meeting place for all Buddhists, and its programs are presented by representatives from: Thailand, Sri Lanka, Mongolia, Indonesia, Taiwan, Bhutan, Tibet, Japan, Myanmar and India. The international participants take active roles in both the Lantern Parade and the World Buddhism Madang. In traditional native dress, international Buddhists introduce their country's unique Buddhist culture, at times with music and dance. You can take memorable pictures and learn the similarities and differences between Buddhist cultures! A venue for learning, the World Buddhism Madang provides a meeting place for expats and multicultural families to share memories of their native countries. Here is a festival within a festival where Buddhists from around the world spend time together.

Writing a Wish _ At the Traditional Cultural Events Madang is a spot where you can leave a writing of your wishes. Writing down and offering a wish for oneself, family or the nation may help you get in touch with your inner self.

Buddhist Painting _ There is a Buddha in every brush stroke. You may glimpse your own inner Buddha immersed in Buddhist painting.

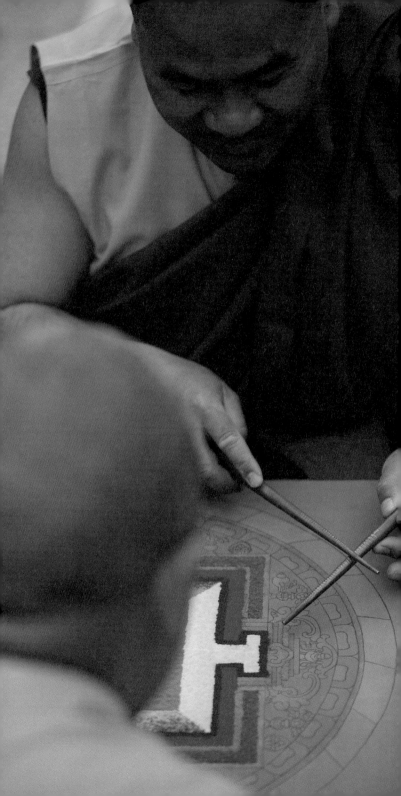

Enjoying the programs prepared by Buddhists from various Asian nations, you will soon forget you are on Jong-ro in Seoul. The World Buddhism Madang is like traveling overseas without ever leaving Jong-ro.

You can hear your own inner voice while "Writing a Wish." You will find yourself hoping good things for others as you read their wishes.

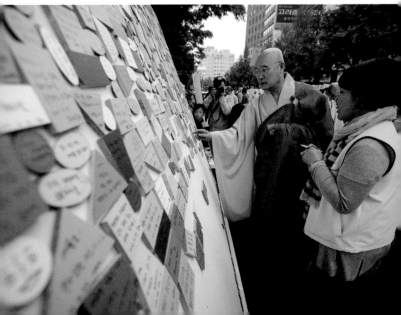

Yeondeung Nori: Final Celebration of the Lotus Lantern Festival

No need to worry if you miss the Lantern Parade, there is still the Yeondeung Nori. As the final celebration of the Lotus Lantern Festival, Yeondeung Nori is held on the last day of the festival from 7 to 9 P.M. The parade of grand lanterns and theatrical troupes starts at Jogyesa Temple, winds through Anguk-dong and Insa-dong, and returns to the 4-way intersection in front of Jogyesa. The streets are again alive with festivities, moving to the melody and beat of the *pungmulpae* (a band of traditional Korean music) as the beautiful lanterns pass by. Everyone waiting for the parade and those who just happen by stop and cheer as the parade passes. The theatrical troupes in beautiful *hanbok* are bombarded with camera flashes as they pass through Insa-dong, a popular tourist spot. Foreign visitors cheer and wave as they snap pictures.

Following the Yeondeung Nori parade, theatrical troupes hold a street dance session in front of Jogyesa Temple. The dance steps from the Eoullim Madang are demonstrated, as well as dance performances by various temple groups. As the performances come to a close, the theatrical troupes, Seoulites and tourists all come together as at the Hoehyang Hanmadang.

*
• Time
Sunday _ 7 – 9 P.M.
(last day of the Lotus Lantern Festival)

• Place
Street in front of Jogyesa Temple, Insa-dong

• Transportation
Subway Line 1 to Jonggak Station
Subway Line 3 to Anguk Station

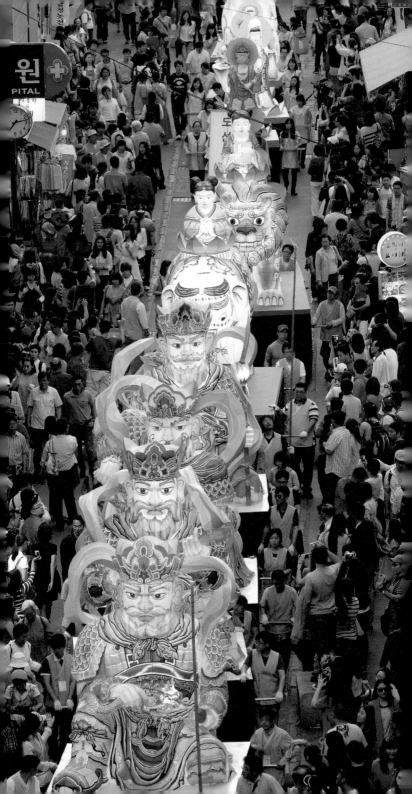

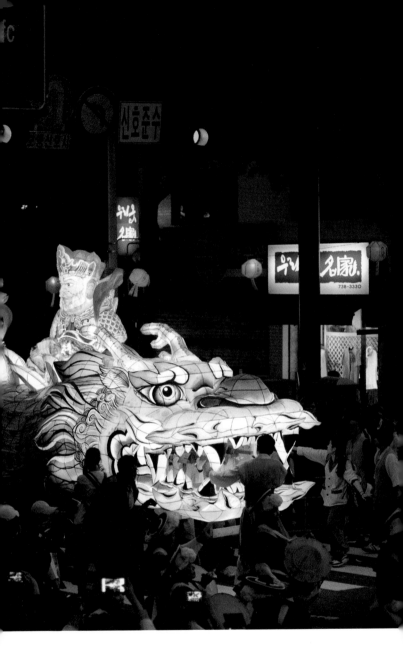

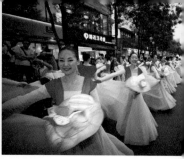

You can watch the theatrical troupes from close up at the Yeondeung Nori. People exclaim and cheer as the parade of troupes in spring-hued costumes and matching lanterns pass by. People are joyous to witness the magnificent parade, and those in the parade are happy to be a part of it.

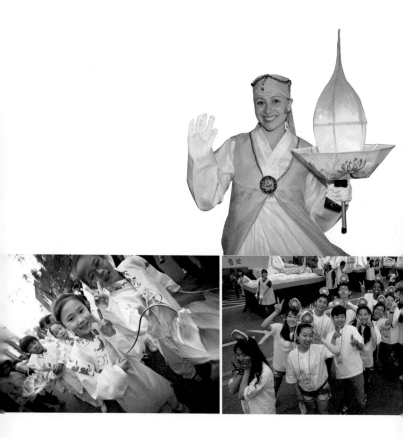

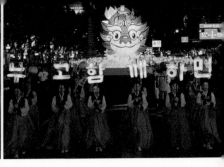

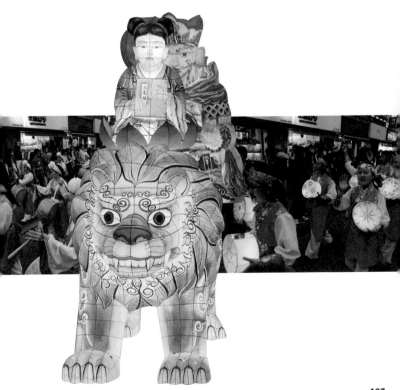

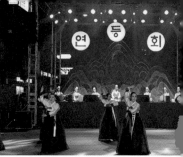

The main players in the Yeondeung Nori are the theatrical troupes. Composed of ordinary citizens, they have prepared for months for the festival. Their non-stop energy and enjoyment to the last of the festival is admirable. Even as the Lotus Lantern Festival winds down, people are looking forward to next year's celebration.

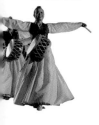

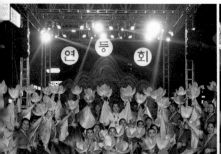

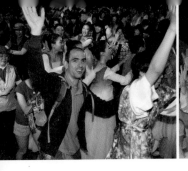
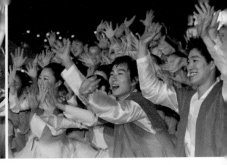
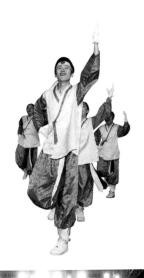
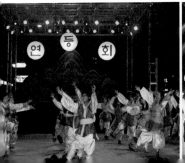
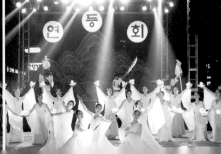

Illuminating the World: A Light That Spreads Over the World

There are two ways to shine a light on the world. One is to light a candle or a lantern. The other is to reflect the light as in a mirror. Acting as a mirror may be to transmit the warmth and love of light. The light of one small lantern for the Buddha centuries ago now spreads throughout the world with the growing number of international visitors at the Lotus Lantern Festival.

According to the Yeondeunghoe Preservation Committee, the average number of foreign visitors at the Lotus Lantern Festival reaches 20,000, with the number increasing every year. Approximately 10% are return visitors. In a recent survey, about 72% of foreign volunteers and 84.4% of domestic volunteers said they would likely return. The volunteers' roles in the festival are by no means passive. Many learn how to make lanterns, join in the parade, perform, carry out miscellaneous tasks or act as monitors. Visitors come from all over the globe, including Nepal, Tibet, Japan, North America, Europe, Africa and Oceania. Over half the foreign participants are in

their 20s, and there is a growing number of teens and the elderly. The religious faiths of foreign participants are: Christian/Catholic 32.3%; non-religious 30.6%; and Buddhists 6.6%.

Visiting from Taiwan, Debbie Yang observed, "The Lotus Lantern Festival seems to be for everyone – male and female, children and adults, individuals and families, foreigners and Koreans. What a shame my camera battery ran out before the end of the parade."

These words faithfully depict the true meaning of the Lotus Lantern Festival.

The light of the Lotus Lantern Festival breaks down all superficial barriers of sex, age, race and religion. It unites us all as one. The light of the festival is ever present, as its spirit lives on in the hearts of everyone.

1 Charm of the Lotus Lantern Festival

Visitors to the Lotus Lantern Festival speak of its many attractions. The favorite element of the festival are the lanterns. All shapes and sizes of lotus lanterns bring joy and light to the spectators, from the small paper-cup lanterns to the grand group parade lanterns that take months to create, as well as the lanterns of more contemporary design. People also enjoy and appreciate the participatory programs, the energetic visitors from around the world, the harmony of religious faiths, the tradition and the hardworking volunteers. Each person at the festival has their own favorites. What is certain is that the Lotus Lantern Festival is a celebration full of beauty, warmth, joy and fulfillment.

Colors and Shapes:
Visual Beauty of the Lotus Lantern Festival

According to research done by the Yeondeunghoe Preservation Committee in 2009, one of the most striking elements of the Lotus Lantern Festival was its visual charm. There are various festivals around the world that celebrate a nation's traditions. The Lotus Lantern Festival goes beyond a visual presentation of the traditional. It is a celebration of light, whose visual beauty people of all cultures identify with. The street lanterns hung across the country on Buddha's Birthday are unique to Korea. It is interesting that native Koreans, along with overseas visitors, find themselves pleasantly surprised to see their everyday streets transformed. Seeing the lotus lanterns all down the street on a spring evening, people find themselves thinking, "This is not the Jong-ro and Seoul I know." The lanterns' soft and muted light seeping through the *hanji* paper is full of mystique. The yellows, reds, blues and greens of the *hanji* paper, the grand lanterns being pulled by many people and the individually carried unique parade lanterns are both touching and impressive. The lanterns in the shapes of shrimp, storks, fish, watermelons and turtles are recreations

of traditional lanterns mentioned in the "A Lantern-Watching Song" from over 1,700 years ago.

Participants often build their own lanterns. Each lantern, even those of the same shape, are individually made and have unique hues, each with its own meaning. Every lantern is one of a kind. These multitudes of lanterns, each one unique, all coming together as a single river of light is indescribably beautiful.

The costumes of the lotus lantern groups add to the festival's visual beauty. Multi-colored *hanbok* takes on varied hues in the light of day and at night. The movements of the *hanbok*-clad participants enhance the visual beauty of the performances. The performances of various temple groups and organizations at the Eoullim Madang are breathtaking. Gathering together at Dongguk University Stadium, the groups perform what they have practiced and perfected for the occasion. The ceremonies of everyone performing in unity are fun to watch. The Lantern Parade begins at Dongguk University Stadium and pulses through Dongdaemun, Jong-ro and Jonggak Pavilion. As it makes its way through the streets, the lights of the parade illuminate the falling darkness. As the river of light enlivens people into cheers, they catch the moment forever in pictures. Light may be the most beautiful thing we can behold.

*
A camera is a must at the Lotus Lantern Festival! Favorite subjects for pictures are:

1 Lotus lanterns and Buddhist symbols
2 Lotus lanterns on the street in front of Jogyesa Temple
3 Participants in *hanbok*
4 *Sunims*, volunteers and lotus lanterns on the Jogyesa Temple grounds
5 Traditional Korean activities
6 Lotus lantern making, lotus flower painting and other activities

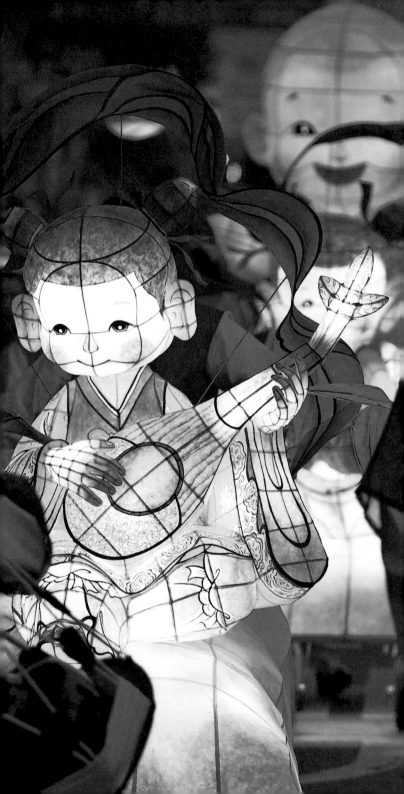

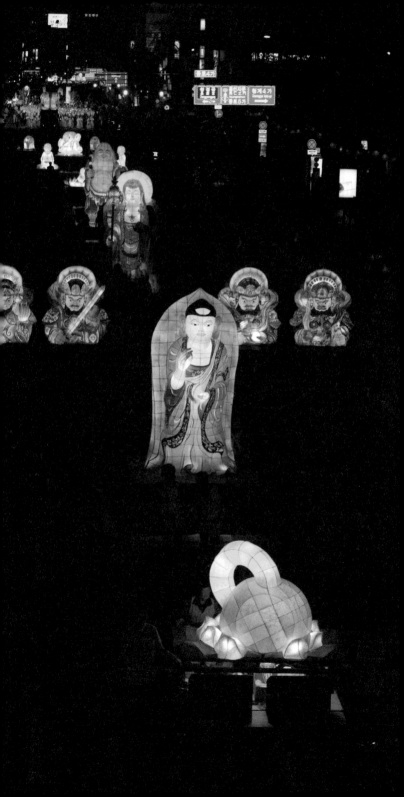

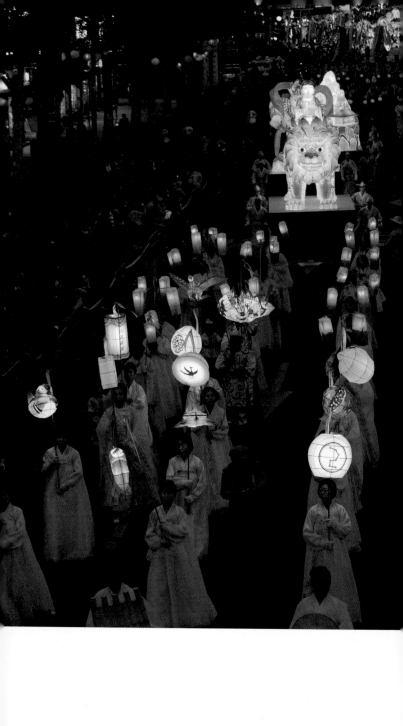

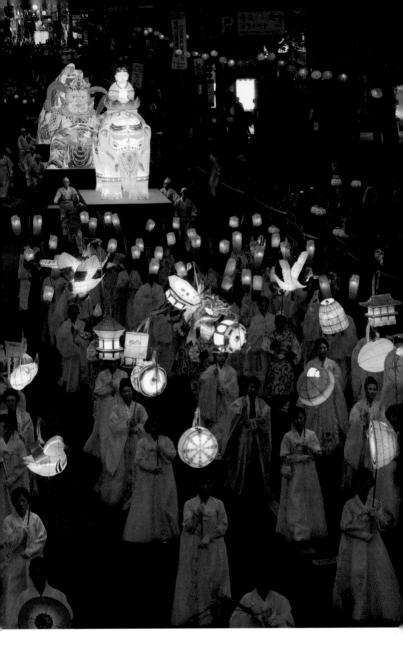

Experiencing Traditional Korean Culture through Buddhism

The Yeondeunghoe, while originally of Buddhist origin, is a deep-rooted Korean tradition with over 1,000 years of history. Koreans historically looked forward to the Yeondeunghoe just as they did the celebrations on New Year's Day, the Lunar New Year and Chuseok (Korean Thanksgiving). Seeing the Lotus Lantern Festival as a Buddhist or religious ceremony is recent. For foreign and non-religious visitors to the festival, the Lotus Lantern Festival is simply a traditional Korean festival. They view the Lotus Lantern Festival as a harmonious mingling of traditional and religious elements, not categorizing it as exclusively either one.

Interestingly, many foreign visitors see the Lotus Lantern Festival as a tradition that is older and more representative of Korea than it actually is. This seems to heighten their expectations for the festival. It is not important to visitors whether the Lotus Lantern Festival is a religious ceremony or a traditional festival. It is enough that they enjoy it as a multifaceted event, where traditional and contemporary, religious and cultural, and Buddhist and Korean values are represented as a harmonious whole.

The festival's more than 1,000 years of history evokes respect. Foreign visitors especially are charmed by the aspects of Korean traditional culture represented in the Lotus Lantern Festival. Many visitors are also interested in furthering their understanding of Korean Buddhism. The religious significance of the Lotus Lantern Festival as a Buddhist tradition and the sacred role of Jogyesa Temple in the celebration are felt to be very special. It is an opportunity to learn more about Buddhism.

The Lotus Lantern Festival, building on people's interest in Buddhism, invites them to pursue wisdom and reflect on how their approach to life. The festival is a celebration of the Buddha's Birthday, the incarnation of a saint. Here it is recognized that, just as the Buddha achieved realization

through dedicated practice, within every person is a Buddha-nature that can be awakened. Upon learning the true meaning of the Lotus Lantern Festival, one sees the hitherto unknown religious aspect of the festival. For those who may have lost sight of what is truly important, bogged down in the complexities of contemporary society, Buddhism's message may be worth listening to. Some may be touched by the austere atmosphere of Jogyesa Temple. Some may see humility and peace on the faces of the monks and nuns, monastics who seem to be of a different world apart from the festival. With the symbol of the pure white lotus that blossoms out of the mud and the parable of the poor woman's lantern, there is an infinite wealth of Buddhist wisdom at the festival. At the Lotus Lantern Festival is a merging of the Buddhist message with traditional Korean culture, and the festival offers the opportunity for people to experience Buddhism. There are programs of Buddhist music and dance that may appeal to the young, contemporary lanterns styled after comic book characters, introductions to mediation and mandalas and the making of Buddhist prayer beads. One American participant at the 2014 Lotus Lantern Festival, Juliet Niguesan, said, "The Buddhist culture experienced at the Lotus Lantern Festival may serve as practical and creative pillars in life. I don't know much about Buddhism, but I enjoyed the elements of calm and patience."

Fun and Laughter: A Festival of Joy

Fun is an important element of festivals. Visitors at the Lotus Lantern Festival are often surprised at the power, energy and excitement displayed. In smiles from beginning to end, each movement of the participants is full of vigor. The pulse of the music, the brilliant lights, the joy of the participants, all the elements come together to make the people cheer.

The Lotus Lantern Festival actually begins at least six months before the festival, when temples and various organizations begin constructing lanterns and preparing the music and performances. The grand float lanterns are made by a team working for months. People often work through the night as the festival date approaches. Without self-motivation, the amount of time and effort required in preparation would be too much.

The shapes and sizes of the lanterns are decided by each temple and organization, without outside direction. The Lotus Lantern Festival is made possible by the hard work of thousands of volunteer participants. The experience of making lanterns and creating cultural events programs serve as a unifying force for the teams. Their reward is the pride of continuing the cultural tradition and sharing the meaning and beauty of the Lotus Lantern Festival. What drives the festival is the voluntary participation of each individual. A festival that one helps to create must be exciting and joyous, and this dynamic energy is palpable to the viewers. One visitor said, "I have never seen such an interesting and colorful festival. Everyone is full of energy, which seems to go on and on." A survey of foreign visitors mentions the festival participants as some of the more memorable aspects of the Lotus Lantern Festival. Visitors to the festival are as touched by the dedication and passion of the participants, as they are the traditional Asian costumes and culture.

The energy of the festival is readily felt by those watching the parade. As the parade participants and spectators wave and hi-five each other, visitors often join in to participate themselves.

As people sing and dance the *ganggangsullae* with people next to them at the Cultural Madang, everyone becomes one in a joyous celebration. This is what a festival should be, a palpable mass of energy created by throngs of people.

Quotes from festival participants:

"There was not a moment of boredom at the Lotus Lantern Festival. People were full of great energy. I normally find even going to the grocery tiring. I couldn't believe that I took part in an all-day event."

"It was hot, busy and full of people, but none of that was a problem. I had a child with me, and that was fine. I wasn't rushed and we had fun at our own pace."

"People from all over the world came to celebrate. I think everyone felt welcomed. Even if you did not subscribe to a religious faith, and whether you were a monk or a Muslim in hijab, everyone was respectfully welcomed."

A festival where everyone comes together in joy, to feel and participate, this is the Lotus Lantern Festival.

*
Some of the words foreign visitors used to describe people they met at the festival:

• Friendly
• Warmth
• Happy
• Smiling
• Amiable
• Sincere
• Patient
• Modest

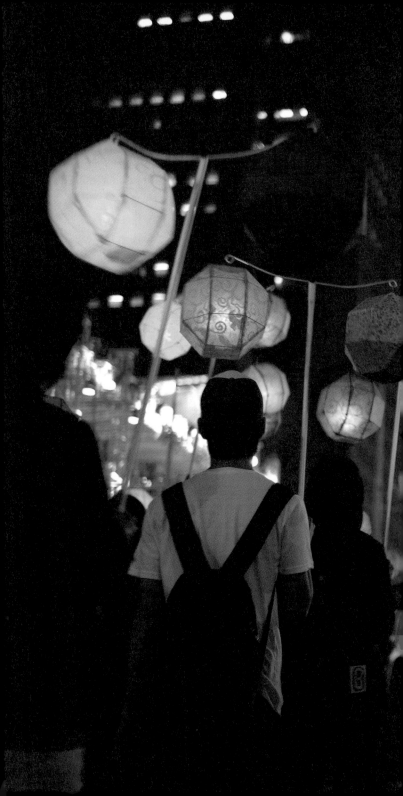

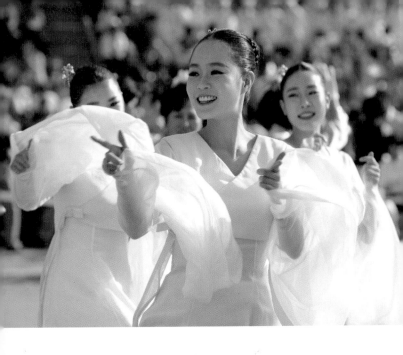

Those experiencing the Lotus Lantern Festival for the first time are often surprised at its dynamic energy and scale. The Lotus Lantern Festival in downtown Seoul, a huge plaza full of people, the experience of becoming one with the joyful energy of everyone; it is an experience full of mystique.

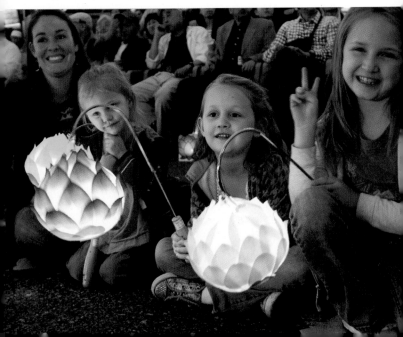

A Simple Joy of Experience and Making Your Own

The Lotus Lantern Festival offers many programs in addition to the main Lantern Parade. Among the many performances, exhibitions and experiential programs, you can choose programs that interest you. At the festival booths in downtown Seoul are programs where you can experience diverse aspects of Buddhist and traditional Korean culture. Some of the program booths offer: making lotus fans, painting multi-colored *dancheong*, transcribing a traditional Goryeo sutra in gold ink, making a good fortune bag, calligraphy of *gahun* and making traditional masks and Korean flags. Time flies as you find yourself immersed in the programs. Also at the festival are international booths representing the Buddhist cultures of various Asian nations. Here representatives from each nation introduce their own unique Buddhist culture, and you can experience and compare the different traditions. People especially enjoy the participatory elements of the festival where they can make, write and draw things. The Cultural Events Madang tends to heat up with the mid-afternoon sun in late spring and a throng of people. Here you can see people immersed in single-pointed concentration, crafting for hours. The high satisfaction ratings of the Buddhist Cultural Madang come from these experiential and participatory programs, a space for you to exercise your creative power. The lotus lanterns, candles, Buddhist prayer beads and Buddhist paintings you create will become memorable souvenirs of the Lotus Lantern Festival. People are happy to participate and take home items of their own creation.

The festival is very popular for its family-oriented programs as well. You often see children sitting in concentration with their parents all across the Buddhist Cultural Madang. Many families come to the festival with grandparents, parents and grandchildren. A festival that appeals to participants of all ages is rare. The Lotus Lantern Festival is proven to be a great festival for families.

"I enjoyed the festival to the very end, even with some thirst, hunger and hot weather. I participated in almost every event."
"I think it's great that you leave with something in your hand. People were so proud of their handmade crafts."
"The Buddhist Cultural Madang was full of things to do. I could go on all day."
The positive experiences at the festival help participants better appreciate Buddhism and traditional Korean culture. It may help them recognize that Buddhism is not so esoteric and foreign. A place where everyone can join in fun, regardless of their religious inclinations or native traditions, this is the value of the Lotus Lantern Festival.

Singing and Dancing as One

The Lotus Lantern Festival is a festival of outdoor plazas and squares, a festival of shared space. The entire festival takes place outdoors: the Gwanghwamun Plaza Lighting Ceremony, the Lantern Parade from Dongguk University Stadium through Dongdaemun and Jong-ro, the streets lined with lotus lanterns, the traditional lantern exhibits and the Cultural Events Madang along Jong-ro. The outdoor setting of a *madang*, a communal space for recreation, enables participation by everyone. Other than the lantern construction for the Lantern Parade, which is done before the festival, all programs can be participated in at the festival. There is no set procedure or age limit for the programs, and you may simply come and join in the fun. Everyone is welcome to follow the Lantern Parade, smiling along with the participants and holding on to each other's shoulders.

The openness of the festival is disarming as people let down their guards and become their understanding selves. You find yourself wanting to participate. Koreans call this *sinmyeong*, which refers to the joy and excitement for life, the refreshing spark of freedom you feel as you find yourself transported beyond the mundane.

This joyous quality reaches its peak at the Hoehyang Hanmadang, the Post-Parade Celebration. The Lantern Parade itself lasts about three hours, but the celebration does not end there. The Hoehyang Hanmadang then heats up in front of Bosingak Pavilion. *Hoehyang* (transfer of merits, total dedication) is a Buddhist ceremony wherein one offers others their own accumulated good deeds and wishes. It is unconditional giving, without any boundaries of gender, age or social class. It is a ceremony of giving back to those around you what you have witnessed of beauty, sincere hearts, happiness, joy and a job well done. This act of *hoehyang* is perhaps the most important ceremony that completes the Lotus Lantern Festival.

As the Lantern Parade reaches Bosingak Pavilion, all eyes

and ears are focused on the parade. A plaza full of people sing and dance under the lotus lantern lights, as they enjoy the performances. The plaza heats up as people dance the *ganggangsullae* dance hand in hand. Holding hands with those around you, the entire square becomes as one. The plaza becomes the performance stage of the *ganggangsullae* with people dancing round and round to the music. It is a spectacle of joyful excitement and heartfelt emotions. At this moment of unity, a shower of flower petals falls from the sky. The pink paper petals fall everywhere and upon everything. People are surprised and touched as the flowers rain down upon their smiling, laughing faces.

It is often the case that the end of a festival brings with it a feeling of emptiness and a desire for more. The Lotus Lantern Festival is a festival where the energy you shared with everyone strengthens you to return to your daily work, as it releases the joy in your heart. An olden Indian proverb says, "A mind at peace finds festive joy in every village." With its pure sincerity, the excitement and joy of the Lotus Lantern Festival prepares you to step into the world anew.

*
Rain of Flower Petals

The flower petals are a small gift from the Yeondeunghoe Preservation Committee to the festival participants. It is the committee's hope that people will keep one and take it home as a reminder of the joy and excitement at the Lotus Lantern Festival. They also hope it may inspire people to come visit next year. While holding the flower petals, people often remember the Lotus Lantern Festival as a joyful experience that lasts and lasts.

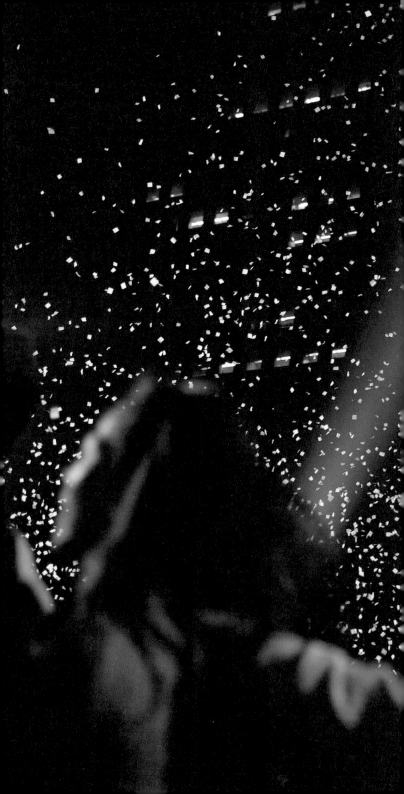

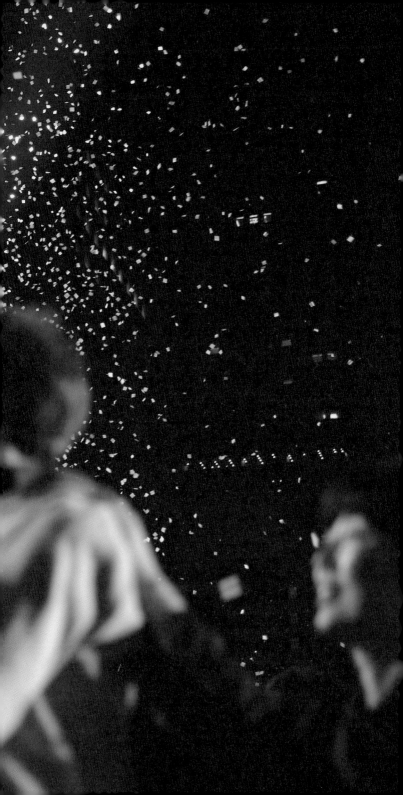

Testimonials of Participants and Volunteers

"I had thought this festival would be heavily connected to Buddhism, but I think it's great that it doesn't try to force Buddhist beliefs on others. It seems as though both foreigners and Koreans are able to get along together to create true harmony."
_ **Kim Gyeong-jin, Korea**

"There may not be many festivals in Korea where one can experience traditional Korean culture. The Lotus Lantern Festival is one where this feeling of tradition really comes out."
_ **Kim Su-bin, Korea**

"Working as a volunteer at the Lotus Lantern Festival was one of the best decisions of my life. It was more than just simple volunteering. It had me stop and think about my life up to now."
_ **Rano Lliyeva, Kazakhstan**

"Making the lotus lanterns was very memorable. It took a very long time to make the lanterns, but the staff was so friendly and helpful. [I was told] 'Oh! Just be a little more patient. It may take some time, but you will soon see

your wonderful results.' It was really warm advice."
_ **Marina Dmukhovskya, Russia**

"What I really remember is how everyone was praying together for the victims by the sinking of Sewol Ferry during the Lantern Parade. The entire country was filled with grief at this unfortunate tragedy so the parade could not be a happy one, but through grieving and praying together it was very meaningful."
_ **Jeong Bo-hyeon, Korea**

"I was deeply impressed how in such a short period of time they changed the theme of the Lotus Lantern Festival to honor the memory of the sinking of Sewol Ferry victims."
_ **Kailue Li, China**

"I have no interest in religion, but they brought together even people without religious faith so that I could learn anew the traditional culture of our country."
_ **Hwang Seon-yeong, Korea**

"I was feeling homesick, so

dancing the *ganggangsullae* circle dance was really good for me. Holding the hands of strangers and dancing together is not something I experience often."

_ **Chan Lan, Malaysia**

"I am a Buddhist but have only ever gone to the temple on the Buddha's Birthday. I thought Buddhist events had to be quiet and a little boring, but there were a large variety of ceremonies. I learned that the Lotus Lantern Festival is one of the Important Intangible Cultural Assets."

_ **Kim Eun-jin, Korea**

"I was surprised that Korean traditional lanterns were so diverse. They were really beautiful. The colors of the Lantern Parade were magical. I saw another facet of Korean culture with the Lantern Parade and traditional clothing (*hanbok*)."

_ **Katherine Ceballos, Panama**

"I was surprised at how many people from other countries volunteered and participated in the Lotus Lantern Festival and showed an interest in learning more about our culture. Their participation and enthusiasm was impressive. The orderly walking through streets as wide as ten lanes was truly unforgettable."

_ **Jeon Yu-deok, Korea**

"I experienced the Lantern Parade

in person. I was surprised at the size and the beauty, and above all I loved the mysterious and peaceful atmosphere of the bright and beautiful lanterns in the parade. The multitude of lanterns that each participating group made really left an impression on me."

_ **Jeon Na-yeong, Korea**

"I was surprised that there were so many other foreigners like me. There was a flash mob to commemorate the sinking of Sewol Ferry, and the exclusion of the elaborate lanterns felt very considerate. 'Sharing in Pain' was written out in candlelight, and I was very moved by people's hearts reaching out."

_ **Eri Jo, China**

"I was still feeling homesick. Holding hands and running around laughing with strangers, giving high fives is an experience I will always remember."

_ **Mun Hae-ri, Korea**

"It is so great that everyone who participates can each return home with their own souvenir. A good memory and a good souvenir. A Buddhist monk took a selfie with me and my friends, which is yet another special memory I will never forget."

_ **Maellige Delliou, France**

The Light of 1,000 Years That Renews Itself

Meaning and Future of the Lotus Lantern Festival

Lee Yunsu•

When trying to describe an exciting event people often use expressions such as "the festival of my life" or "today is a festive day." At these times the word "festival" symbolizes "that which makes the heart beat excitedly," "awesome fun," "rapturous enjoyment" or "exhilaration and passion." Have you experienced these emotions at Korean festivals? In retrospect, such emotions may have been experienced by all Koreans during the 2002 Korea-Japan Would Cup games when all of Korea united behind their team. Technically it was not a festival, but emotionally, it was. Through word of mouth, everyone put on red T-shirts symbolizing the team and rushed to numerous plazas around Korea where jumbotron screens had been set up for the event. People sat together with complete strangers and cheered until their throats were raw, hugging each other and dancing after every Korean goal. It was an event where everyone became one regardless of age, social class or regional sentiment. From the very first game up to the third place play-off, the desire for victory was brimming over. The streets became plazas, and the plazas became sanctuaries of freedom. Whether it was wearing the national flag or blowing horns in the middle of the night, all taboos were temporarily permitted. And in the midst of this joyful coming together was voluntary action.

While not every Korean was an enthusiastic soccer fan, there was a collective desire to experience the joy of victory and the deep feeling of oneness. Such excitement cannot be recreated in a planned venue. Joy, passion and enthusiasm come alive where a crowd rushes to gather, even when under the weather, to witness an event. That is the power of voluntary participation, where the excitement starts from the bottom and bubbles up. Such is the root of a successful festival.

Our neighbor Japan is a country of festivals. Every Japanese village holds some sort of festival. Residents are proud of their traditional festivals, carried on in the same way their ancestors did. During a festival, everyone gets time off from work, and people travel back to their hometowns in order to participate. The voluntary excitement of the participants is the strength that has guided Japanese festivals for hundreds of years.

Korea also has such historical festivals. It is written of the ancestral rites of Buyeo and the harvest festivals of antiquity that, "During the ancestral rites, people eat, drink, sing and dance every day." Until about fifty years ago, each village held ancestral rites to the Dongshin God, protector of the village. On the first full moon of the lunar New Year and on Chuseok, the inhabitants of each village held ancestral rites and played *chajeon nori* (chariot battles) and danced the *ganggangsullae*. These were large-scale festivities. These festivals were sometimes interrupted by history, from the suppression of the Japanese annexation period, the US military government's misrepresentation of the festivals as superstitious practices and the "New Community Movement" when streets were widened and thatch-roof houses demolished. There is one traditional Korean festival that has continued to this day, a festival that people have celebrated for over 1,300 years; it is the Lotus Lantern Festival. What is the history and the spirit that has allowed the Lotus Lantern Festival to continue on?

•
Visiting Professor, Korea University
Characteristics of the Cultural Contents and History of the Lotus Lantern Festival
(Ph. D. Dissertation, Korea University Graduate School)

The First Light of Korean History

The Lotus Lantern Festival is a celebration of light. The word *yeondeung* refers to the act of lighting a lantern. In Buddhism, the lantern is one of the six offerings made to Buddha. Through these six offerings, a person may achieve the six perfections to help them reach enlightenment. Amongst these six perfections, the lantern represents wisdom. To light a lantern is to realize one's ignorance and to open the door to wisdom. The lantern is a metaphor for disciples who retain and pass on the truth their teacher has passed on to them. The scriptures also tell the story of "A Poor Person's Lantern." In this story, a poor woman spends the few coins she has received from begging to buy a lantern, which, in the story, shines brighter and longer than the lantern of the king. In this parable, the lighting of a lantern is strongly emphasized as an act of sincerity.

The first historical record of the Yeondeunghoe is in *The Chronicles of the Three States*. In the year 866, it was recorded on the first full moon of the lunar New Year that, "King Gyeongmun of United Silla (r. 861-875) made a royal visit to Hwangnyongsa Temple to view the lanterns, and held a feast for all the government officials." Lanterns were then already a

"On Buddha's Birthday in the fourth month of the thirteenth year of King Sejo's reign, the festival was held at Wongaksa Temple." (the *Annals of Sejo*). This tells us the Lotus Lantern Festival was still observed in Joseon.

This picture appeared in the May 27, 1928 edition of a newspaper. A crowded Jong-ro is hung with lanterns. (From the *Korea Daily News*)

custom during the Unified Silla period. That the king left his palace and traveled to Hwangnyongsa Temple to view the lanterns suggests they were quite a spectacle. He did not only enjoy viewing the lanterns, he also held a feast for his officials. Embroidering the night sky, the lights of the lanterns would have provided a harmonious backdrop for the dinner. This is the standard form of traditional festivals.

By the time of Goryeo, the Yeondeunghoe and the Palgwanhoe Festival had become national events. Amongst "the Ten political guides" which King Wang Geon of Goryeo (r. 918-943) left to his descendants, he requested that "The king and his vassals take pleasure in firmly pledging to respect and enforce the lantern festival." In obedience to this, generation after generation of kings held a lantern festival each year. King Hyeonjong of Goryeo (r. 1009-1031) moved the festival from the first full moon of the lunar New Year to the full moon of the second lunar month, which was the day of Buddha's entering Nirvana. In differentiating his lantern festival from the Chinese lantern festival which took place on the first full moon of the lunar New Year, King Hyeonjong had expressed a sense of independence. Although occasionally moving the festival back to the first full moon of the lunar New Year in order to avoid a month of mourning for a king or queen, the lantern festival was celebrated on the day of Buddha's achieving Nirvana for 137 years until the reign of King Injong of Goryeo (r. 1122-

1146). During the Goryeo Dynasty the lantern festival was celebrated as a two day holiday, on which days the curfew was lifted. The festival was divided into a day of private festivities on the fourteenth day of the second lunar month and public festivities on the fifteenth day. On the first day, after an exclusive ritual held in the living quarters of the palace, the king went to Bongeunsa Temple in the evening, paid respects to the portrait of the first king of Goryeo, and returned. As he returned to the palace after the ceremony at the temple, the road was illuminated with lanterns. It was recorded that, "the light of the lanterns extended to heaven and it was as bright as day." The lantern festival spread across the entire country. Confucian scholars also joined in the celebrations; it was a festival that transcended the boundaries of religions. On the second day, the king and his vassals had a gala during which they shared food and alcohol. This feast was spread out late at night on the evening of the lantern festival. The king composed poems and the vassals responded by praising the king's charitable deeds. Confucian scholars, including Kim Busik, also left us poems about the beauty of the lanterns.

Expressions of a Desire for Harmony

Previously held on the fifteenth of the month, the lotus lanterns came to be celebrated for the Buddha's Birthday in 1166. A eunuch by the name of Baek Seonyeon was the first to record that, "On the Buddha's Birthday lanterns were lit along with prayers of good fortune. The king observed the event." Considering that the king traveled to a branch temple to view the lanterns, the event must have been considerably large. Regular observance of the Yeondeunghoe on the Buddha's Birthday began with an extravagant lantern festival held by Choe Woo in 1245 during the Goryeo Military Regime. Choe Woo was the major leader of this regime, its power nearly acknowledged as a dynasty. He likely could not acknowledge the lantern festival on the 15th of the lunar month as it was a symbol of the Goryeo royal family. The grand royal visit of the king from the palace to Bongeunsa Temple was discontinued. Instead, a *chaebong* (a stage of various colors for song and dance performances on nationally recognized days of celebration)

Yi Jongak, a classical scholar of Joseon, left us this painting of the great spectacle of Andong City's Yeondeunghoe as seen from Bangudae Rock. This painting is called the "Bangu Lantern Festival." The red dots depict all the lit lanterns. Even in Andong, the mecca of Confucianism, every house put up lanterns and enjoyed the Yeondeunghoe.

was erected, and a *deungsan* 燈山 (mountain of lanterns) was built, accompanied by various plays.

At the end of Goryeo, the Yeondeunghoe celebrated on the fifteenth day of the month was forgotten, and replaced by the festival on the Buddha's Birthday which became the people's festival of choice. The people hung and lit rows and rows of lanterns and went sightseeing to enjoy the lanterns once night had fallen. Unlike other events overseen by the state, the Lotus Lantern Festival was driven by the enthusiasm of the people from start to finish, for even if no one told them, they would make lanterns on their own to enjoy the grand spectacle.

The Yeondeunghoe continued even into the Joseon Dynasty which had been founded on Confucian philosophy. The royal family also celebrated the lantern festival on the first full moon of the lunar New Year until the reign of King Seongjong (r. 1469-1424). King Sejo (r. 1455-1468) held the Yeondeunghoe Festival at Wongaksa Temple on the Buddha's Birthday in 1467 to commemorate the completion of a ten-story pagoda there. And for the next 500 years, diverse lanterns were lit in the palace on the Buddha's birthday, which became a seasonal custom. Amongst the populous, the Yeondeunghoe on the Buddha's Birthday became a very popular event. The curfew was lifted and "men and women swarmed the streets throughout the night enjoying the games." It was a festival when the night became as bright as day.

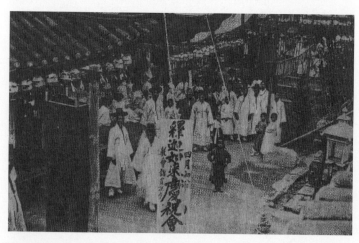

Gaeseong City on Buddha's Birthday during the Japanese Colonial period/ Japanese Occupation.

The Parade of Lights: India, China to Korea

The lantern parade originated in India where Buddhism began. Traditionally there was a *san'geo* (mountain wagon) and a *haengsang* (float) festival. A *san'geo* refers to a wagon in the shape of a temple upon which images of gods were enshrined and paraded through the streets. *San'geo* refers to a parade in which images of various gods are carried, and *haengsang* refers to a parade with an enshrined statue of Buddha. The tradition of *haengsang* eventually passed from India to China, and in India, Sri Lanka and China, a *haengsang* took place on the Buddha's Birthday.

In India, the statue of Buddha previously carried in the *haengsang* evolved into a five-storied pagoda supported by as many as twenty carriages. This form of Buddhism also spread, along with the parades, to the streets of Sri Lanka. In China, a statue of Buddha was placed above an elephant lantern. The large crowds that came to view the grand spectacle of the *haengsang* occasionally resulted in injuries and causalities. In India, the land where the gods live, a grand *san'geo* festival is still held. There is a sense of wild excitement which has kept this parade festival going for 1,500 years; to the extent that some people continue to crowd around the wagon and throw themselves upon the wheels, which measure over two meters in diameter. In China, the *haengsang* parade disappeared in the Yuan Dynasty, and the lantern festival became central. The tradition of the *haengsang* parade did not appear again until the early 1940s in Beijing. The eminent Chinese Buddhist Master Taeheo wrote of the Japanese-style celebration that took place on the Buddha's Birthday during the Japanese occupation: "At the Hall of Heavenly Kings in Beihai Park in Beijing, the ceremony of bathing the Baby Buddha was held. Four grand images of elephants led the way around the center of Beijing." It was a show of resistance to Japanese imperialism that the traditional *haengsang* festival was resurrected. This refutes the misconception that the Lotus Lantern Festival is a vestige of Japanese imperialism.

The Grandest Street Parade in Korea

Large parades were already taking place in Korea beginning from the Three Kingdoms Period. From the third to the beginning of the fifth century, twelve-section Goguryeo murals depict images of kings and nobles in processions. In these murals are the standard depictions of men on horseback, flag bearers, infantry, royal guards, musicians and dancers. As murals from the third century depict a standard order of parade participants, it may be assumed that the procession had been institutionalized by then.

The parade tradition became firmly entrenched in Goryeo through the Yeondeunghoe and the Palgwanhoe Festival. The king paid a royal visit to Bongeunsa Temple during the Yeondeunghoe and to Beobwangsa Temple during the Palgwanhoe. In the evening when the lanterns were lit and the king went to and from Bongeunsa Temple, or when he went to and from Beobwangsa Temple, his entourage consisted of a minimum of 2,000 people. It was a very large parade.

A description of a Silla era parade can be found in a record of how the *Avatamsaka Sutra* of Silla came to be written. On the way to where the sutra was being copied, ten people walked in front of the procession and spread incense and flowers. This parade evolved into *gyeonghaeng*

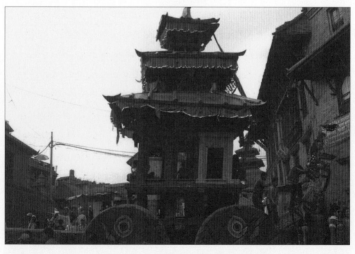

In India and Nepal, the custom of enshrining images of gods in parades continues today. This *san'geo* is reassembled and used every year.

經行(slow walking meditation) of Goryeo. Walking meditation, originally a ceremony to dispel disaster and illness, has the appearance of a parade. Three groups walked the streets of Gaeseong, but instead of a statue of Buddha, they carried a copy of the *Inwang-gyeong* (*Sutra of the Benevolent Kings*) in a painted sedan chair and carried it in a street parade. As Buddhist practitioners paraded the streets reading the sutra and burning incense, government officials in official dress followed. The public prayed together and walked behind the parade or stood in the streets and watched. The custom of *gyeonghaeng* meditation was also seen in the Joseon Dynasty in the ceremony to relocate and enshrine the *Goryeo Buddhist Canon in Eighty Thousand Woodblocks*. The *Goryeo Buddhist Canon in Eighty Thousand Woodblocks* were moved from Seonwonsa Temple on Ganghwado Island to Jicheonsa Temple in Hanyang (modern day Seoul). The *Annals of King Taejo* says the king made a royal visit to the Yongsangang River to see the moving of the woodblocks. "The monks of all five Buddhist orders recited the sutras while others were made to follow with incense. The honor guard led the way beating drums and playing the pipes." In this procession, 2,000 soldiers moved the wooden blocks. During the reign of King Sejo (r. 1455-1468), the king also participated in *gyeonghaeng* meditation.

This scene from the 1958 Lantern Parade foreshadows today's parade. In 1958 people also rode in army Jeeps piled high with lanterns to resemble mountains.

This procession was led by *beon'gae* (ornaments in the images of flags and umbrellas) and followed by a sedan chair in which a small statue of Buddha was enshrined. Musicians were at the front and back of the procession. Hundreds of monks paraded to the left and the right, while the chief monk beat a drum atop a wagon. In paying respect for the Buddha, the king came out of his palace to Gwanghwamun and saw off the parade. It was said that "the sounds of the drums, pipes and Buddhist prayers reverberated up to heaven" and "the ladies of nobility gathered in throngs to watch." It was a grand street parade in a time when such large events were a rarity.

With hope and prayers for the peace and stability of the nation, the custom of *gyeonghaeng* meditation was re-enacted for the first celebration of the Buddha's Birthday after liberation from the Japanese in 1946. The parade went from Taegosa Temple (Jogyesa Temple) through Anguk-dong and Jong-ro to Changgyeonggung Palace, and a statue of Buddha was enshrined in a sedan chair and carried through the streets. The lantern parade held in 1958 after the Korean War was led by ten trucks that were adorned top to bottom with lanterns. In the lead of the 1959 lantern parade were six trucks carrying six adornment lanterns in the shape of white tusked elephants, similar to the Indian *haeng'sang*. In this manner, the tradition of *haeng'sang* and *gyeonghaeng* meditation are preserved in today's Lotus Lantern Festival.

In the context of its historical background, the Yeondeunghoe was designated Korea's Important Intangible Cultural Heritage No. 122 in April 2012, as "a ceremony that has endured through disruptions and changes from Unified Silla to the present – a ceremony in which the people participate voluntarily." The Lotus Lantern Festival has maintained its form and tradition of voluntary participation for the past 1,300 years in spite of the changing times.

A Day for New Clothes and Rest: The Lotus Lantern Festival and Characteristics of Seasonal Customs

Seasonal customs have developed from the cycles of planting and harvesting which are fundamental to agricultural societies. Along with agricultural influences, religions, including Buddhism and Confucianism, have also contributed. Festivals have evolved around these seasonal customs. *Jecheon* harvest traditions of ancient Korea evolved into the Yeondeunghoe and the Palgwanhoe Festival. "The Ten Political Guides" left by King Taejo of Goryeo stressed that the traditions of the Yeondeunghoe and the Palgwanhoe Festival must continue. Of the nine holidays observed during the Goryeo Dynasty, the Yeondeunghoe on the first full moon of the lunar New Year and the Festival of Palgwanhoe were respectively called *sangwon* and *palgwan*. At the end of the Goryeo period, the Yeondeunghoe was moved to Buddha's Birthday and became a national holiday.

The lantern festival was a day when even non-Buddhists and young children donned new clothes for a day of recreation. It was an important seasonal custom for people to make preparations and buy or make a new set of clothes. As customary for the New Year, people wore new clothes on Buddha's Birthday. *Seasonal Customs and Games*, a book published by Seoul City in 1992, records that on Buddha's Birthday, non-Buddhists also visited temples for activities and play. They also circumambulated pagodas and enjoyed *hwaryu nori* (a picnic in spring, celebrating beauty of nature in blossoms). Throughout history, the Full Moon Lantern Festival, and later the Yeondeunghoe on Buddha's Birthday, was a day for people to make a wish by hanging a lantern at a temple, and to view the grandeur of the brilliant lanterns irrespective of personal faith.

The seasonal tradition of special costumes continues today in the Lotus Lantern Festival. Foreign visitors include seeing the lanterns and the people in *hanbok* as their most memorable impressions of the festival. All the festival's participants, from parade marchers to volunteer workers, wear *hanbok*. Unlike Lunar New Year and Chuseok, where

wearing *hanbok* has become a rarity, the Lotus Lantern Festival retains the tradition of wearing a special traditional outfit in celebration of the holiday.

Lighting a Lantern for Enlightenment and for One's Neighbors: Characteristics of Religious Ceremony

In both the East and West, traditional festivals were often a part of ancestral rites and religious ceremonies. People enshrined their gods in sacred places and often prepared a sacrifice to communicate with the gods. The gods then departed, having been satisfied. Through offerings, festivals were a venue where gods and humans could interact. The recreation and entertainment elements emphasized in today's festivals are a deviation from the original sacred rituals. The original features of religious rituals are difficult to recognize even in today's traditional festivals.

It is when the ritual and sacred characteristics of a festival are retained that participants experience some sense of spiritual unity. This sense of unity is the driving force of a festival and creates social cohesion. The Lotus Lantern Festival retains its religious ritual features unlike most other festivals, while keeping the original form of a festival.

The Yeondeunghoe celebrates the birth of the Buddha, who demonstrated that a person could attain enlightenment through their own efforts. It is a day to remember and confirm that one can attain enlightenment through devotion and diligent practice. The Yeondeunghoe offers the gift of light to the Buddha, who gave us the light of wisdom. It shines a light on the virtues we lack and our own self-deceptions, while holding out a light for our neighbors. To make a lantern and take part in the parade is to participate in a sacred act. Offering a wish by lighting a lamp is also a sacred act that transcends the mundane. The Lotus Lantern Festival overflows with joy and enthusiasm, because just as in the story of a poor woman's lantern, people offer their time and effort in sincerity to prepare for the festival. This enthusiasm is the vital driving force that energizes the festival and the key to its success. The Lotus Lantern Festival reaffirms every year the sacred unity of spirit, as people create, enjoy and share together.

Some argue that the Lotus Lantern Festival is a ceremony for Buddhists only. Not true; it is a Buddhist festival that embodies Korea's traditional culture, a festival wherein Korea can share its culture with the global community.

Beyond Age, Race, Gender and Religion: Cultivation of Community Spirit

Traditional Korean society took as its ideal the concept of a "*daedong* society." A *daedong* society prized faith, loyalty, harmony, responsibility and consideration of others. *Daedong nori* performances were often held to put into practice this ideal of a society without discrimination. *Daedong nori* was an event to solidify the process of working, building, enjoying and solving things together. That is how modern festivals evolved. As in the parable of the poor woman's lantern, the Lotus Lantern Festival demonstrates the *daedong* spirit, from the sincere preparation of lanterns beforehand, to the final *hoehyang* ceremony of giving back and sharing what you have gained through the festival. The production of lanterns is a group effort that requires sharing opinions and the exchange of know-how. Such a group effort requires a foundation of harmony and consideration for others. Taking part in the

parade with the completed lantern is also a practice of group spirit. In a parade, each person must keep pace with the others, and you become as one in song and dance. While walking together in the parade and looking at each other and laughing, you share intangible human qualities.

The highlight of the Lantern Parade is the Hoehyang Hanmadang at Jonggak Pavilion. This is where men and women, old and young, all enjoy *daedong nori* hand in hand, and experience together the rain of flower petals from the sky that will bring good fortune. This is the zenith of the festival where people transcend the boundaries of race, age, gender and religion and become one in the spirit of *daedong*.

Re-energizing to Face the Mundane: Recreation as Cleansing

You leave the daily grind behind when you go to a festival. A festival is a time to forget yourself in wild enthusiasm, in a world different from your everyday life. Anthropologists have defined festivals as "a time of overthrow," "the shedding of daily life," "a reversed world" and "liberating life." In a world that has left behind the everyday, taboos and limits are no longer. In a world that sheds the mundane life, authority, order and basic knowledge become meaningless. A festival is a place

full of fantasy, delight, emotion and excitement you cannot experience in everyday life; it is a time for catharsis.

A successful festival generates enthusiasm. How many festivals make it possible for participants to shed their humdrum daily lives and then return to them re-energized? The Lotus Lantern Festival is full of opportunities for the expression of emotions, for purification of self and for shaking up everyday reality.

The moment you begin walking with others in the lantern parade, the street you are on is no longer simply "the street between Dongdaemun and Jong-ro." You leave behind your name, along with the countless labels seemingly attached to you. Wearing the *pail-bim* and parading with your lantern, it is a time of deliverance from the everyday.

As people dance the *ganggangsullae* under a rain of pink flower petals at the Hoehyang Hanmadang, the Lotus Lantern Festival brims with great excitement and joy. Participants release their suppressed emotions and stress. The festival being a time to immerse oneself in joy, passion and a sense of freedom, it serves as a cleansing and purifying experience to strengthen you for another day.

The Lotus Lantern Festival, with the Lantern Parade as its representative event, is a festival of joyful excitement in its essence and a time for catharsis and re-energizing.

A Festival of Diverse Cultural Contents

Along with the Templestay program, the Lotus Lantern Festival has
developed into a significant cultural phenomenon. Even with little
promotion, there is a substantial number of foreign visitors at the Lotus
Lantern Festival. At the heart of the festival's success are the lanterns.
The Yeondeunghoe Preservation Committee has worked diligently to
recreate traditional lanterns and foster development in lantern crafting
by training traditional lantern artisans and passing on the craft to other
major lantern festivals. In the process, the Lotus Lantern Festival has
become a benchmark for "one source, multi-use" events (developing
one content through various methods).

The Jinju Namgang Yudeung Festival that began in 2002 and the
2009 Seoul World Lantern Festival are both lantern-centered festivals
influenced by the Lotus Lantern Festival. The lanterns displayed at the
annual Seoul Lantern Festival are loaned out for free the following
year to various regional festivals. This has made possible small lantern
festivals for the enjoyment of local residents in other regions. It has
been noted that the focal point of these festivals are the grand lanterns
over three meters in height. Traditionally, the essence of lantern festivals
was in small individual lanterns rather than grand lanterns. In the
future, more emphasis on smaller handcrafted individual lanterns may
be in order. In developing festivals to attract foreign visitors, increased
use of traditional lanterns, as seen at the Lotus Lantern Festival, is
recommended. This could make festivals more environmentally friendly
as well. A truly great lantern festival would have properly constructed
traditional lanterns, which may entail a reduction in lantern size.
Cultivating future lantern artisans and assisting them financially are
also recommended. Programs that allow participants to make their
own lanterns is a must. A festival where small individual lanterns come
together to build the whole would have longevity.

The number of festivals that display and make use of lanterns has also
increased, and they tend to revitalize the region they are held in. The

Hwacheon Sancheoneo Ice Festival in Hwacheon-gun is one such festival; it celebrates ice fishing for trout. At this festival, 500 meters of street are festooned with trout lanterns (*seon-deung*), a sight that has become a trademark of the festival. The tradition of the "wish lantern" (*somang-deung*) has also taken on an important role at various festivals. The act of lighting a lantern as a wish is an inherently human act. To light a lantern and make a wish is an act that everyone can understand, regardless of age, gender or religion. Wish lanterns light up the night and radiate a feeling of hope at a festival.

Lantern crafting as an experiential cultural program is expanding. Hanging wish lanterns as part of a sunset or sunrise ceremony has become a seasonal custom, especially to greet the New Year. As the tradition of wish lanterns grows in popularity, the use of traditional *hanji* lanterns over imported plastic lanterns are to be encouraged. The Lotus Lantern Festival can encourage people to continue passing on traditional crafts to regional festivals and revive the meaning of traditional lanterns.

The Lotus Lantern Festival with its 1,300 years history is a festival of pure energy and passion and one of the most popular Korean festivals for foreign visitors to attend. At present, there are over 1,200 festivals held annually in Korea. The Lotus Lantern Festival is one of the highest rated,

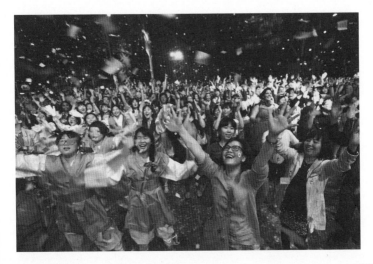

by both native Koreans and foreign visitors. Many festival organizers assess the Lotus Lantern Festival to be an excellent model.

It is the sincerity of voluntary participation that has brought about the festival's success. Many festival organizers overlook the essence of a true festival. Bureaucracy and the commercialization of some festivals make the error of viewing festival participants as objects of consumption and mobilization. A festival that does not put participants at its center does not last.

The Future of the Lotus Lantern Festival: A 2014 Perspective

The Lotus Lantern Festival of 2014 demonstrated the festival's qualities as a living heritage. Ten days before the festival, the sinking of Sewol Ferry occurred. In a show of condolence and solidarity, memorial altars were set up across the country, along with waves of yellow ribbons in the streets. Scheduled festivals were postponed or canceled. With five days left to the festival, the Yeondeunghoe Preservation Committee announced that the Lotus Lantern Festival would proceed in the form of a memorial for the dead.

From that day on, festival participants worked day and night to create new lanterns in white (the color of mourning in Korea) to share the pain of the bereaved families in the spirit of *daedong*. Bathed in white, the

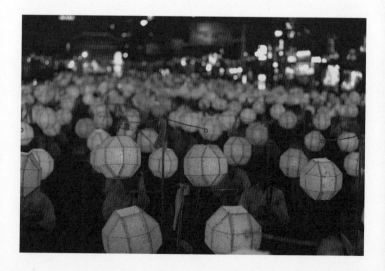

parade took place, holding and embracing the loss. The streets flowed with white lanterns, and Jonggak Station, normally overflowing with the excitement of *daedong nori*, became a venue to soothe the spirits. This normally festive occasion was now a sea of tears, with prayers for the return of the missing. In five days, the Lotus Lantern Festival, where people normally enjoyed enthusiastic chaos to escape the routine of daily life, had transformed into a scene of deep condolence and emotion. In the spirit of national mourning, the Lotus Lantern Festival took on the role of a sacred place of prayer and a memorial for the dead. This was a true festival in that it was made possible by the strength of volunteership. Making and lighting one's own lantern and taking part in a joyful celebration of the lantern culture, the deep roots of the Lotus Lantern Festival grow from the passion of the participants.

The Yeondeunghoe Preservation Committee works to provide an environment in which people can take an active role. There is no "producer" or "director" at the Lotus Lantern Festival. It is not a superficial, carefully-orchestrated, one-time event. The Lotus Lantern Festival remembers its origin that began with the lantern of a poor woman, a festival where everyone can participate to their hearts desire and join in a collective happening. The committee works to provide support for the participating groups in their preparations for the festival. With the participants as its foundation, the festival is full of great energy. The Yeondeunghoe is a holiday and a festival for Korean people that has continued through times of peace and hardship. In times of darkness, the Yeondeunghoe comforted the people. In times of peace, it offered fun, joy and excitement.

The Lotus Lantern Festival has continued its tradition through the work of its participants, who on their own create lanterns and make the festivities. The Yeondeunghoe continued even in the Joseon era with its Confucian policy of suppressing Buddhism. People hung as many lanterns on Buddha's Birthday as they had family members, raising high beacons of light. During the Japanese annexation period, people faithfully donned the special *pail-bim* outfits and hung lanterns, continuing their own customs in spite of the loss of self-governance. A product of devout passion, the Lotus Lantern Festival continues today to follow the unwavering pulse of its deep and profound history.

History of the
Lotus Lantern
Festival in Pictures

In the long history of the Lotus Lantern Festival, there are few records to trace its evolution. The first reference to it is in *The Chronicles of the Three States* where King Gyeongmun of Unified Silla is said to have visited Hwangnyongsa Temple to view the lanterns on the fifteenth day of the first lunar month. A record of the Yeondeunghoe as a national event also appears in the 10 Political Guide (*Hunyo sipjo* 訓要十條) of King Taejo Wang Geon of Goryeo. Various other historical, literary and pictorial representations from the Goryeo era, including *Dongguk sesi-gi*, also reference the festival.

Photographic records of the festival in modern times begin in 1955. The pictures show how the people put together simple lantern festivals of joy. Here is the evolution of the Yeondeunghoe in pictures.

1955-2015

While held on April 8 of the solar calendar during the Japanese annexation period, the Yeondeunghoe returned to Buddha's Birthday in the fourth month of the lunar calendar with the liberation of Korea. Temporarily downsized during the Korean War, celebrations of Buddha's Birthday picked up again at Dongguk University after the war. The year 1955 is important in the history of the Lotus Lantern Festival. In a form similar to today's Lotus Lantern Festival, Seonhagwon Buddhist Academy, Cheongnyongsa Temple and other Buddhist temples came together at Jogyesa Temple for a paper lantern parade. Since then the parade has followed the route from Dongguk University to Jogyesa Temple.

The Chosun Ilbo (May 29, 1955)

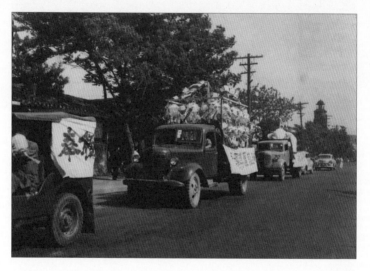

1958

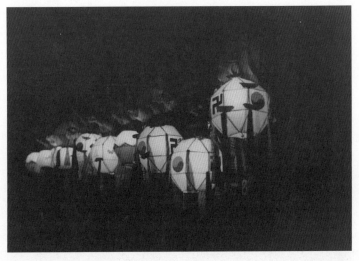

1958

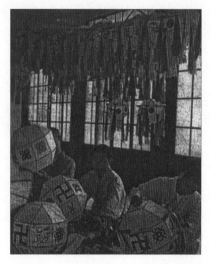

1960

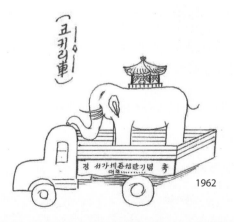

(코키리車)

경 차가세준법만기념 촉

1962

The lantern parade did not take place in 1960 and 1961 due to the April 19 Revolution (1960) and the May 16 Military Coup (1961). A magnificent celebration of Buddha's Birthday was held in 1962 when various Korean Buddhist orders united and established the Jogye Order of Korean Buddhism. The *Korean Daily Report's* headline read, "Buddha's Birthday and Our Folklore" on May 12, 1967. The article reported that more than 10,000 Buddhists participated in the Lantern Parade, displaying a variety of lanterns. The lantern festival officially became a part of Buddha's Birthday celebration in 1968.

The Chosun Ilbo (May 2, 1963)

The Korean Daily Report
(May 12, 1967)

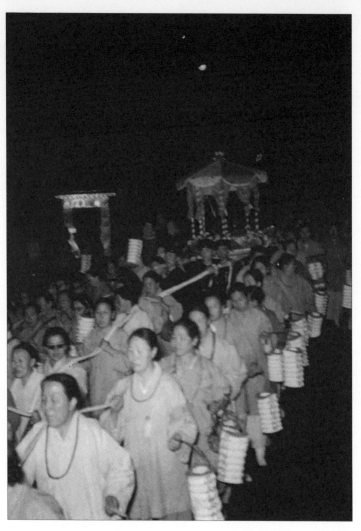

1969

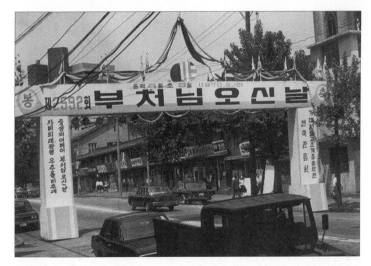

1970

During the 1970s, the Lantern Parade was led by young student groups. Their fingers pink from lotus flowers used to dye the lanterns, students worked on the lanterns for a month and participated in the parade with lanterns representing their schools. Full of idealism, the lanterns were rough around the edges but most endearing. Clumsy lantern crafting skills and all, students were greeted warmly by the crowds. As seen in the white elephant lantern manipulated from inside, the simple and charming student lanterns brought great joy to everyone.

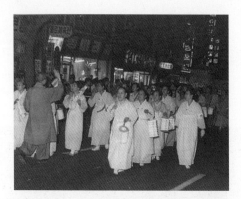

1971

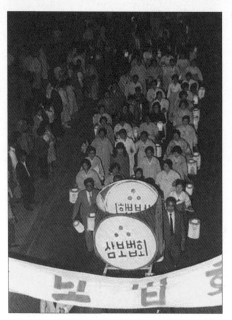

1971

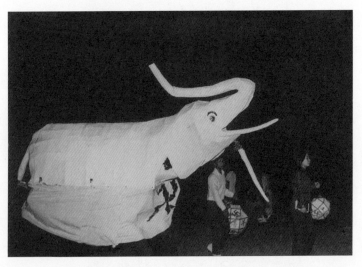

1972

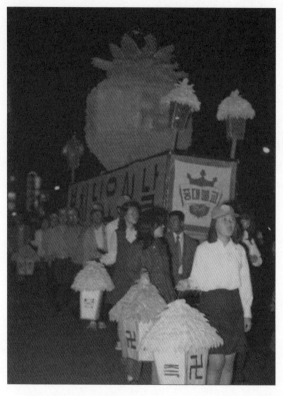

1973

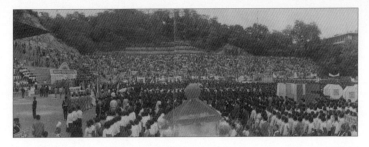

1975

With the designation of Buddha's Birthday as a national holiday in 1975, a large crowd came together at Dongguk University for the festival. To accommodate the larger and larger crowds, the lantern festival events were eventually moved to Yeouido Plaza. The parade followed the 11 km route from Yeouido to Jong-ro for the next 20 years.

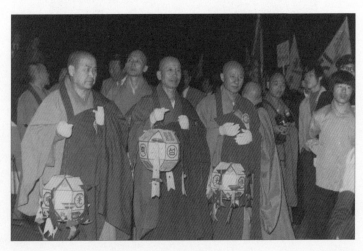

1975

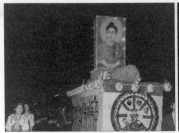

1976

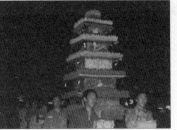

1977

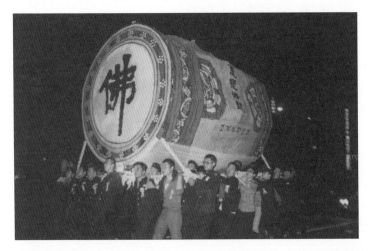

1979

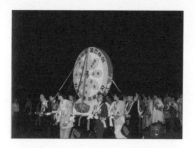

1981

1983

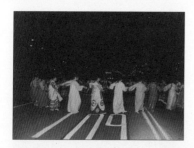

1984

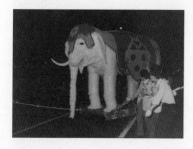

1985

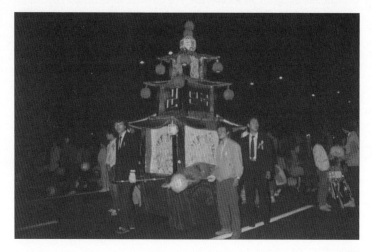

1986

The Lantern Parade was suspended in 1980 under martial law following the May 18 Gwangju Democratization Movement. In the atmosphere of expanding democratization movements in the 1980s, the university students' parade proceeded in spite of concerns it could develop into a demonstration. Colliding with the police, the parade at times continued amidst exploding tear gas and sit-ins.

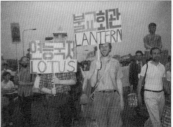

1987

1988

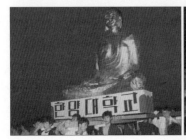

1989

1990

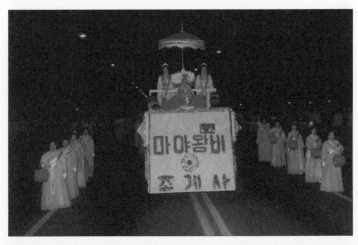

1991

In 1994, the Lantern Parade route was changed to start at Dongdaemun Stadium and proceed to Jogyesa Temple. This was done because the Yeouido ~ Jong-ro parade route was determined to be impractical for the elderly and children. It was also suggested that a shorter parade route with more programs and events could increase participation. This created the environment for the parade to develop into a full-scale festival.

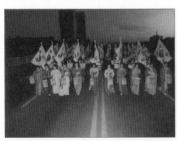

1992

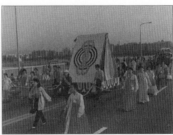

1993

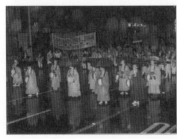

1994

1996

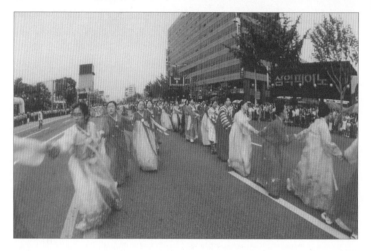

1996

1998

2000

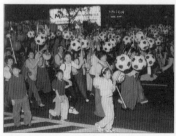

2001

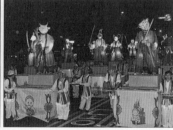

2002

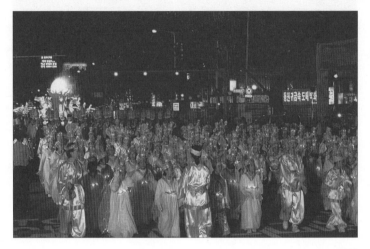

2003

If 1996 was the year the foundation of the Lotus Lantern Festival was laid, 2002 was the year of improving the festival's structure to better suit social conditions. In order to accommodate the increasing number of participants and foreign visitors, the street festival was changed to the Buddhist Cultural Events offering various programs. The Lantern Lighting Dharma Assembly grew into the Eoullim Madang in Dongguk University Stadium, an event for all participants to come together. The Hoehyangsik Ceremony changed its name to Daedong Hanmadang, as a form of traditional *madang nori* (outdoor games). The change was made to provide people a space for festive fun. Lotus lanterns in the shape of soccer balls were designed for the 2002 World Cup, which was held partly in Korea. The number of foreign visitors to the Lotus Lantern Festival increased rapidly from then on.

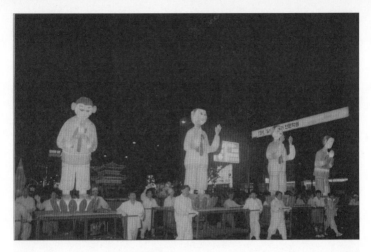

2004

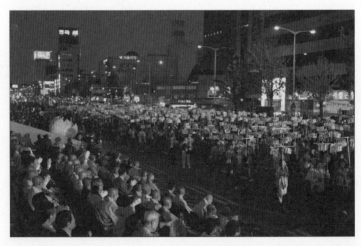

2005

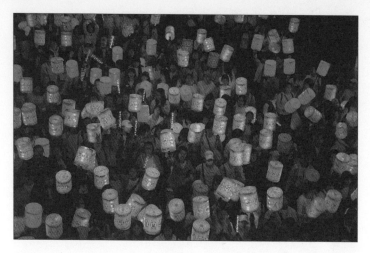

2006

Beginning in 2000, classes in grand lantern making were offered.
Lantern crafting skills continue to develop year after year, evident in the
impressive grand floats. The Lotus Lantern Festival became a venue for
creative and participatory fun. Lanterns of all shapes and colors, made
by each individual, come together in a show of harmony; this is the real
charm of the festival.

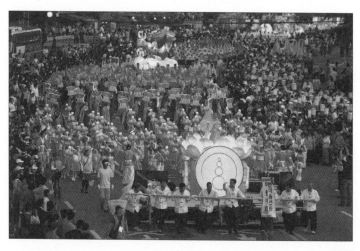

2007

2009

2011

2012

2013

The Yeondeunghoe was designated Important Intangible Cultural Heritage No. 122 in 2012. It was in recognition of the festival's status as an integral and vibrant part of Korea's heritage. It was also a cause to celebrate a 1,300-year-old Silla tradition, Goryeo's Yeondeunghoe and Joseon's Gwandeung Nori.

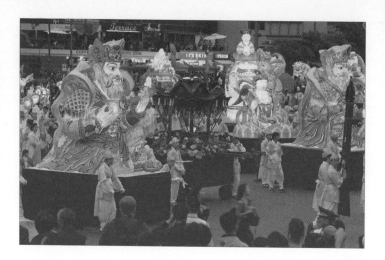

2014

2015

Lotus Lantern Festival Information

How to Make a Lotus Lantern

In Buddhism, lanterns symbolize wisdom and hope. Korea's traditional lanterns are a beautiful heritage that gave us light in times of darkness. The lanterns embody and radiate out our hopes and dreams, along with our prayers for family and neighbors. The lanterns of the Lotus Lantern Festival are special in that they are created by people working together toward a common goal. The lanterns are built in sincerity, from the moment of their conception to the moment they are lit.

In its efforts to promote the development of lantern crafting, the Yeondeunghoe Preservation Committee hopes to preserve traditional lotus lanterns and pave the way for more beautiful handcrafted lanterns. Seeing the steps and processes involved in the lantern crafts may help you understand the time and effort invested in making each lantern.

1 Participating in the Lotus Lantern Festival

Information on the Lotus Lantern Festival can be found on the official Lotus Lantern website, along with various official social networks and community sites, including Facebook, Twitter and mobile apps. Highlights of past Lotus Lantern Festivals and dance routines are available on the official Lotus Lantern Youtube Channel.

- Lotus Lantern Festival Homepage: www.llf.or.kr
- Lotus Lantern Festival Facebook: https://www.facebook.com/LLFLLF
- Lotus Lantern Festival Twitter: https://twitter.com/lotuslantern2
- Official Youtube Channel: http://www.youtube.com/user/LotusLanternFestival

2 The Symbol of the Lotus Lantern Festival

The symbol of the Lotus Lantern Festival is a pure lotus flower rising

up from the mud. The three petals joined together symbolize all of humankind coming together in harmony, while the three dots, representing the flower's fragrance, stand for *Triratna*, the Three Jewels of Buddhism (the Buddha, the Dharma, the Sangha).

3 How Best to Enjoy the Lotus Lantern Festival

• Suggested Itinerary for Saturday

2 P.M.	View the Traditional Lantern Exhibition: Jogyesa Temple, Bongeunsa Temple, Cheonggyecheon Stream
5 P.M.	Have supper: Insa-dong neighborhood
7 P.M.	View the Lantern Parade: Jong-ro area
9 P.M.	Participate in the Hoehyang Hanmadang (Post-Parade Celebration): Jonggak Intersection (scheduled to end around 11 P.M.)

• Suggested Itinerary for Sunday

2 P.M	Experience the Traditional Cultural Events and the Cultural Performances : Madang: in front of Jogyesa Temple

5 P.M	Have supper: Insa-dong neighborhood
7 P.M.	Yeondeung Nori (Final Celebration of the Lotus Lantern Festival): Insa-dong Street (in front of Jogyesa Temple)
9 P.M.	View the performances of festival participants: in front of Jogyesa Temple(scheduled to end around 9 P.M)

4 International Support

In expanding the Lotus Lantern Festival into an international festival that betters our understanding of Korean Buddhism, the Yeondeunghoe Preservation Committee has offered a support program for foreign visitors since 2013. As Honorary Ambassadors of the Lotus Lantern Festival, International Support members, consisting of 50 Koreans and 50 resident foreigners chosen through one month of online and offline promotions, participate in various activities in and around the festival. Beginning a month and a half before the festival opens, these volunteers meet weekly and receive education about the history and meaning of the Yeondeunghoe, the history and culture of Korean Buddhism and Buddhist etiquette, as well as participate in the Templestay program. During the festival they provide guidance to foreign visitors at the Lantern Parade and Traditional Cultural Events Madang, as well as help run the activities. When the festival ends, they take part in an evaluation of the events and volunteer activities. The evaluations of the volunteers are used to better the festival for the following year, improving what was lacking and highlighting what received favorable responses.

The satisfaction of participants involved in the International Support program is very high. They noted a sense of pride and accomplishment, and making friends from various cultural backgrounds as positive experiences. Volunteer opportunities for foreigners living in Korea being difficult to find; the foreign resident participants gave positive feedback for the chance to personally interact and work together with native Koreans.

- Time Commitment: Two months before the Lotus Lantern Festival until after the Lotus Lantern Festival
- Inquiries: Yeondeunghoe Preservation Committee

5 Visitor Favorites at the Lotus Lantern Festival (2014)

Classification		Number of Respondents	Viewing of the Lanterns and Parade	Many Diverse People	Various Cultural Experiences	Diverse Program Experience	Buddhist Culture Experience	Other
Whole		77	45.5%	15.6%	5.2%	10.4%	13.0%	10.4%
Nationality	Korean	37	37.8%	13.5%	8.1%	10.8%	13.5%	16.2%
	Foreigner	40	52.5%	17.5%	2.5%	10.0%	12.5%	5.0%

Comments of International Volunteers

_____ "I think that the Lotus Lantern Festival surpasses the level of simply being a religious event. It reflects the history and culture of the participants and inspires fun and harmony amongst them. It is a cultural festival which preserves Korea's culture and allowed me to get a true feeling for the country."

_____ "It was a very good opportunity to meet new people and learn more about Korean Buddhism. I learned a lot about Buddhism and spent time with many good friends. It was also a good opportunity to share what I had learned with other people. I will never forget this experience."

_____ "I was able to learn teamwork while pulling the magnificent grand floats. Being able to participate directly in the parade and have fun through taking a leading part in the festival finale was really great. The sense of belonging that I got from the Yeondeung Festival Volunteer Group made me feel proud."

_____ "I did not have any interest in religion before the activity, but through International Support I studied about Buddhist culture. This excellent culture brings everyone together, even those people in Korea who don't believe in religion."

_____ "The participation of many and diverse people left a deep impression. Meeting people who had all sorts of different life styles was very enjoyable."

6　How to Make a Lotus Lantern

Traditional lanterns are an important part of Korea's cultural heritage. The design and motifs of the lanterns have grown ever more diverse with the creativity of the lantern makers. The lanterns have evolved alongside Korea's history. Unfortunately, the tradition of making one's own lantern has faded over time. The Yeondeunghoe Preservation Committee is working to disseminate traditional lantern craftsmanship. The effort to revive traditional lantern making allows you to experience firsthand what is involved in making a traditional lantern.

How to Make a Parade Lantern.
Steps of the Parade Lantern Crafts

1　Designing
2　Preparing the materials and tools
3　Making the lantern frame
4　Affixing *hanji*
5　Painting (decorating)
6　Attaching the wish
7　Lighting the lantern

- **Lantern materials**: wire (or choice of traditional material), *hanji*, thread, glue, paint, brush, scissors, pliers

1 _ Designing

The design is the most important part of the lantern making process. One must consider the shape and materials, the sequence of steps, the use and storage of the lantern and other such factors. When visualizing the lantern shape, include in the plan the size of the base (front view), the side view and the elevation (top view). The lantern will be made based on this plan. Next consider different framework designs and interior structures for different lighting methods (electricity, candle etc.).

2 _ Preparing the materials and tools

Wire which is easily bendable is used for the lantern frame. The gauge (diameter) of the wire should be proportional to the size of the lantern. Other traditional materials such as bamboo and bush clover may

also be used, as well as a variety of other materials including wooden chopsticks, straw and clear plastic bottles.

3 _ Making the lantern frame

Place a sketch of the lantern on a flat surface and make the frame to match the lines. Shape the wires as necessary and attach them together with tape.

4 _ Affixing *hanji*

Hanji used for parade lanterns must be thin yet strong as it determines the brightness of the lantern. Glue is used to attach *hanji* onto the frame. Pay attention to the amount of glue used as too much glue may make painting difficult.

5 _ Painting (decorating)

Any material may be used for decoration. Using pre-designed patterns, painting, pasting on patterns, hanging decorations (tassels), cutting or ripping and any other method may be used. When painting, controlling the opacity of the traditional watercolor paint is important. When drawing a design on the lantern, it may be easier to use tracing paper rather than drawing directly on the lantern (see the painting section for octagonal lanterns).

6 _ Attaching a Written Wish

In attaching a written wish to the lantern, consider the objective of lighting the lantern and how the written wish harmonizes with the lantern as a whole. The paper material, color and phrase should all work together.

7 _ Lighting the lantern

When using a candle, install the candle holder and candle support in the lantern. Make an opening at the top to avoid the lantern catching fire. When using a light bulb and battery, a support fixture that can be tightly secured to the wire is necessary.

1 Designing

2 Preparing the materials and tools

3 Making the lantern frame

4 Affixing *hanji*

5 Painting (decorating)

6 Attaching the wish

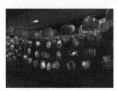
7 Lighting the lantern

How to Make a Small Lotus Lantern

A small lotus lantern made from a paper cup is called a cup lantern. It is a small and beautiful lantern, and easy to make.

Lantern materials: paper lotus petals, paper cup, glue, wire or string, awl

1 _ Apply glue to the end of the paper lotus petals and roll.

2 _ Using the awl, make two holes on opposite sides at the top of the cup and attach the wire or string to make a handle.

3 _ Attach the paper lotus petals, starting from the open top of the cup.

4 _ Attach another row of petals, making sure to maintain the right distance between this line and the first line. While attaching the petals, pay attention to the upper and lower parts and both sides so that the lantern is well balanced.

5 _ After attaching three rows of petals, attach a row of green leaves. The leaves are attached to bend down in a direction opposite from the petals.

1

2

3

4

How to Make a Watermelon Lantern

A watermelon lantern is a traditional lantern in the shape of a watermelon and can be easily made from a frame consisting of six circles. Attaching a variety of cutout patterns or drawing different pictures on it will give a new and unique design.

Lantern materials: bamboo or wire for the frame, tools for cutting the bamboo or wire (wire cutter, tape measure, saw etc.), thread, instant glue, *hanji*, painting supplies (paints, brush, water), scissors, wood glue

1 _ Making the frame

Bend the long bamboo or wire into six circles. Tape these circles together one by one into the shape of a cube to make the frame. Make a candle holder in the shape of ⊥ letter and attach it to the bottom circle.

2 _ Affixing *hanji*

When affixing *hanji*, keep in mind that the overlapping sides must match exactly. Before attaching the paper, decide which side to glue on first. Spread glue on the side of the frame you want to attach the paper to and then press a piece of paper over it. Trim away the remaining paper, leaving 5~8 mm beyond the edge of the frame. Make a notch with the scissors every 2 cm on the part you will attach, then apply the glue. Start attaching the other pieces, starting with the triangular sides (the sides on which you will draw the stripes of the watermelon).

3 _ Painting

Draw your sketch on the paper and then paint, starting with the triangular sides. Paint the circular sides bright red and then later use an ink stick (or a marker) to draw the seeds.

4 _ Applied designs

The circular sides may be decorated any way you wish. Drawing other designs or attaching different patterns will give the lantern a new look.

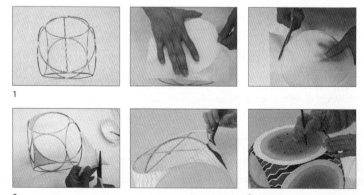

1

2

3

How to Make an Octagonal Lantern

Octagonal lanterns are an all-time favorite as they are easy to make. The lantern materials can be easily obtained at Buddhist supply stores near Buddhist temples, as they carry wire frames for self-assembly.

Lantern materials: wire (frame assembly kit), *hanji*, paints, glue, brush, scissors, knife, ruler, pliers, wire cutter

1 _ Making the frame

The octagonal lantern wire frame consists of two parts. Make sure that the pieces match up before fastening them. The shape of the bottom and top sides must be the same, and the side you attach the candle must go on the bottom. Next use pliers to press the overlapping pieces together so that the wire does not collapse. Attach the wire for the handle diagonally across the top side.

2 _ Affixing *hanji*

When cutting out the paper, make sure to consider the frame length and surface area of the lanterns, and leave margins for applying the glue. Minimizing the margins and keeping them uniform will create a nice lantern. In order to prevent wrinkles, apply the glue and then pull the paper taut on both sides while attaching it.

3 _ Painting

Wait for the *hanji* to dry completely before painting for an even application. When painting, consider the color change with the light on and off. The design may be drawn on directly, using a pattern. Transparent tracing paper may also be used. Draw a design on the tracing paper. Place the tracing paper on the lantern and redraw the pattern on the flip side of the tracing paper. This will stencil the pattern onto the lantern. Painting directly on the lantern without a rough drawing gives it a unique charm as well.

4 _ Cutting and pasting paper

After choosing a pattern and colors, layer together the pieces of *hanji*. Holding the sample pattern down on the paper, cut the papers. Glue

the cutout pattern on the lantern and wrap a colorful strip around the frame to complete the lantern. Apart from the existing traditional patterns, folding layers of colored paper and cutting them with scissors to create a unique pattern makes a beautiful lantern as well.

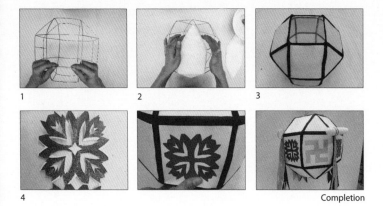

1

2

3

4

Completion

YEON DEUNG HOE 燃燈會
LOTUS LANTERN FESTIVAL
THE LIGHT OF A THOUSAND YEARS

© Yeondeunghoe Preservation Committee 2015
55 Ujeongguk-ro, Jongno-gu, Seoul, Korea
Tel: +82-2-2011-1744

First Edition January 20, 2016
Written by Lee Sumin, Lee Yunsu
Designed by Koodamm
Illustrated by Kim Jeany, An Jaeseon
Photography by Ha Jikwon, Choi Baemun,
Yeondeunghoe Preservation Committee

English Edition
Translation June Park et al.
Translation Assistance Heewon Park, Natasha Rivera, Kyrie Vermette
Editing Consultant Park Hyeran

Published by Bulkwang Publishing
3F 45-13 Ujeongguk-ro, Jongno-ku, Seoul, Korea
Tel: +82-2-420-3200